AMERSHAM

THROUGH TIME

Colin J. Seabright

AMBERLEY PUBLISHING

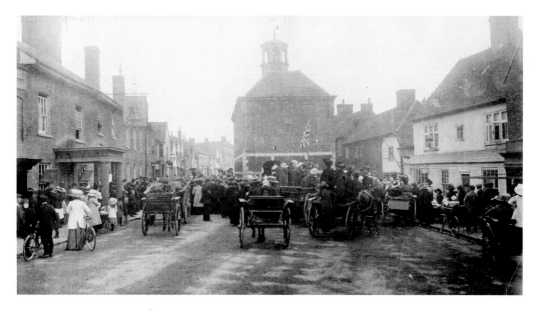

The Town Hall and Market Square
The 'trademark' scene of the town, instantly recognisable as Amersham's Market Square, in front of the town hall, was the traditional venue for various important events, including the official proclamation in 1910 of the accession of George V, pictured here.

First published 2009

Amberley Publishing Plc
Cirencester Road, Chalford,
Stroud, Gloucestershire, GL6 8PE

www.amberley-books.com

Copyright © Colin J. Seabright, 2009

The right of Colin J. Seabright to be identified as the Author of this work has been asserted in accordance with the Copyrights, Designs and Patents Act 1988.

ISBN 978 1 84868 404 1

British Library Cataloguing in Publication Data.
A catalogue record for this book is available from the British Library.

Typeset in 9.5pt on 12pt Celeste.
Typesetting by Amberley Publishing.
Printed in the UK.

Introduction

Amersham is a small Chiltern market town in the valley of the little River Misbourne. It had a population of only 2,674 at the start of the twentieth century, and that included the 128 inmates of the workhouse. Since the seventeenth century the whole town had been owned by the Tyrrwhit-Drake family and very little was allowed to change in the historic High Street; the few additions were at the benevolent squire's expense for the benefit of the residents, and in keeping with the existing buildings.

After Squire Drake sold up in 1928, the rural district council maintained that enlightened policy of preservation and the town was later confirmed as a conservation area, with a high proportion of listed buildings. The High Street is a particularly attractive mixture of mostly sixteenth- and seventeenth-century houses, many re-fronted in the eighteenth century, and the whole has been described as a living architectural museum.

Although many railway schemes were proposed in the early nineteenth century for lines through the Misbourne Valley en route to Aylesbury, Oxford and the Midlands, all were obstructed by the Drake family, who didn't want their peace disturbed and the view from their Shardeloes mansion spoilt by trains, and they refused to sell any land for railway purposes. Then, at the end of the century, the Metropolitan Railway planned an alternative route through Amersham Common, along the Chiltern ridge overlooking the town, where the Drakes had no influence. The construction of Amersham station over half a mile from the old town, at the top of a steep hill, initiated Metroland-style housing development on the fields there, away from the old town. The four individual communities, all parts of Amersham (until the recent

formation of Little Chalfont as a separate parish), now have a combined population of approximately 20,000, or nearly a hundred times that of a century ago. The majority of the growth took place in Amersham-on-the-Hill and Little Chalfont where convenient stations on the new railway and initially reasonable season ticket rates encouraged London commuters to settle. Amersham old town avoided this initial growth due to its distance from the station, and hardly any development occurred there until the '30s, when car travel began to obviate the disadvantage of remoteness from the station, and building was then only on a small scale, and away from the historic heart of the town.

The High Street, in particular, remains untouched by any modern construction, and the newest building there is still the Methodist Church of 1899. Minor changes have been made to the frontages and many shops have closed (in 1900 fifty-six shops sold food and other everyday goods, but now there are only a handful, all providing luxury goods and specialist services). The only major changes have been to the east of Market Square, where demolition took place before the Second World War for slum clearance and to ease traffic congestion, and a bus garage and a meat processing plant were built, both by local enterprises. When these closed their place was taken by a large supermarket.

Because of its old-world appearance, Amersham has always been a tourist attraction, and early in the twentieth century many day trippers from London arrived by train, happy to stroll down the hill to their destination. In the early days of motoring the wide High Street, part of the main road to Aylesbury, could provide ample parking space without hindering through traffic or spoiling the view. Later the increased demand for parking places necessitated the use of part of the meadow next to the gasworks as an official car park. The opening of the Amersham bypass in 1987 took much of the through traffic away from the High Street, but the opening of the supermarket at the end of Broadway encouraged more cars back into the town. Unfortunately random parking still continues along the High Street, in spite of the yellow lines, with the result that many of today's scenes are littered with parked cars and the photographs are consequently much less attractive than the early views.

The new community around the station on the edge of Amersham Common was not initially distinguished from the rest of the common and the name Amersham-on-the-Hill did not appear in maps and

directories until 1915. Development there was both rapid and virtually continuous until well after the Second World War. The new town soon overtook the old as a business centre to become the commercial heart of the district.

Along the hilltop to the east, on another part of the common, once an extensive tract of heathland with a few well separated farms, limited development started in the late Victorian era, forming a separate community which is still known as Amersham Common. Building here was limited to the south side of the main Amersham to Rickmansworth Road, as the Duke of Bedford, who owned the land on the other side, refused to allow development there, although he had sold a strip of that land for construction of the railway line. In 1920 he had a change of heart and sold off the land between the railway and the main road for building. More recently some of the Victorian cottages and the remaining farmland have made way for more housing and light industrial development.

Further along the hilltop road, where a side road descends into the valley en route to Chalfont St Giles and Chalfont St Peter, a station, initially named Chalfont Road, opened on the new railway, later becoming the junction for the branch line to Chesham when the main line was extended to Aylesbury. Very few new buildings appeared around this important rail and road junction for several years and Chalfont Station Village remained little more than a few scattered farmhouses among their extensive fields. Gradually, those south of the railway gave up their fields for housing and Little Chalfont, as it was renamed in 1925, spread toward Chalfont St Giles. North of the railway, the Duke of Bedford released some of his land for housing in 1935, but little building took place before the war, after which growth was rapid.

The pictures reveal very little change in the heart of the old town in the last century but considerable difference elsewhere in the district. They are arranged in a topographical sequence, firstly the old town from west to east, followed by the hilltop communities in the same general direction.

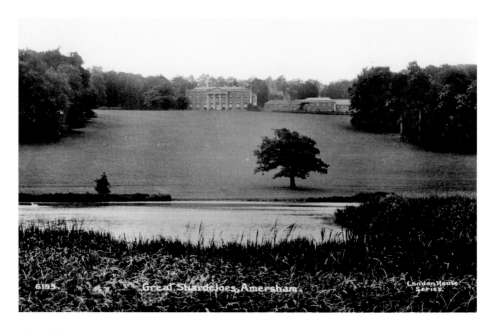

Shardeloes

At the west end of the town, Shardeloes, ancestral home of the Drake family, squires of Amersham, stands in its park, overlooking the ornamental lake created by damming the flow of the Misbourne where it enters Amersham. Pictured in 1910, the river's flow was then sufficient to power two mills in the town, but excessive abstraction of water near the source of the river has severely reduced its flow, and in recent dry periods the lake has virtually dried up, allowing shrubs and trees to thrive in the exposed rich soil of its bed.

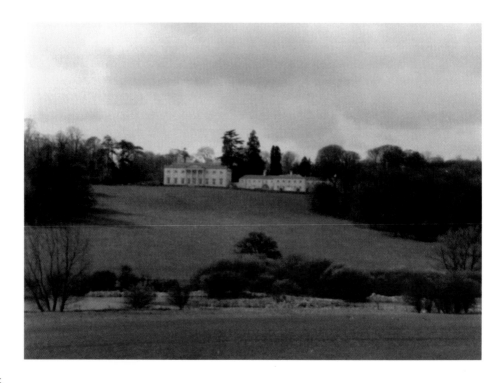

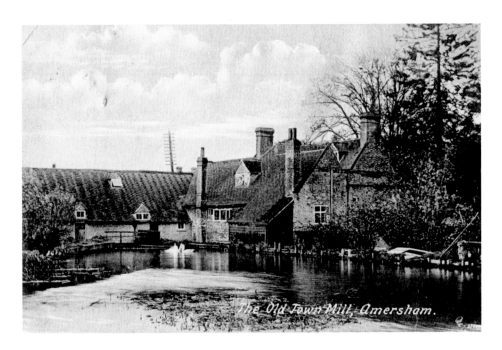

Town Mill Pond

A little way downstream from Shardeloes, the Misbourne-powered Town Mill. Built in the sixteenth century, it is pictured in about 1900 over the millpond, with the old mill house to the right. Part of the pond was used as a public bathing place in the '20s. The mill ceased operation in 1938 on the death of the miller, the mill wheel was scrapped for salvage and the mill building modified internally for residential use. Part of the pond was then converted into a private swimming pool, and later filled in as a garden with the much reduced stream running through.

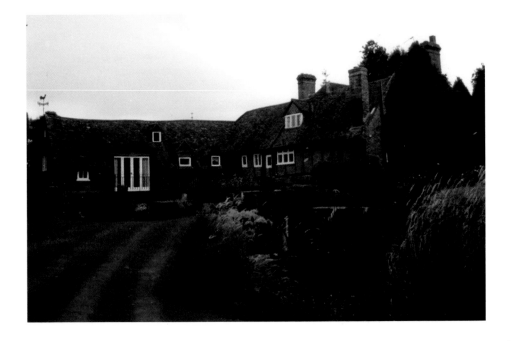

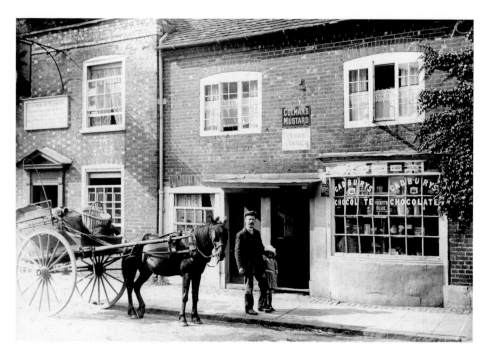

Baker's Bakery

In this 1925 view, Tom Baker, accompanied by one of his three children, stands with the delivery horse and cart outside his bakery shop next door to the Eagle pub. His speciality was bread baked on the premises from local flour stone-ground at nearby Town Mill. He remained in business for another two decades, after which the shop became a tobacconist and confectioners, but is now a private house.

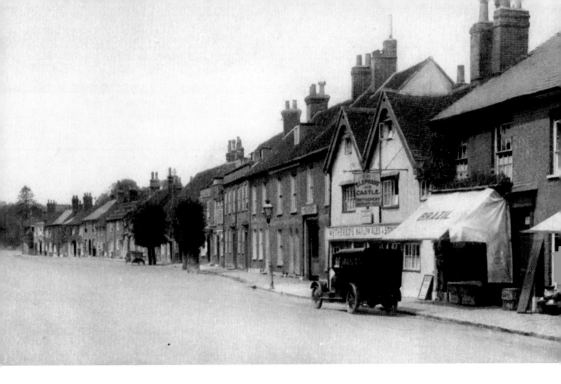

The Elephant and Castle

This 1915 postcard shows the western end of High Street, including the seventeenth-century Elephant and Castle. To the right of the pub, Brazil's van stands outside their butcher's shop, where the first of their famed sausages were made in the back kitchen. The general scene is little changed today, only spoilt by parking permitted within the extreme width of the road.

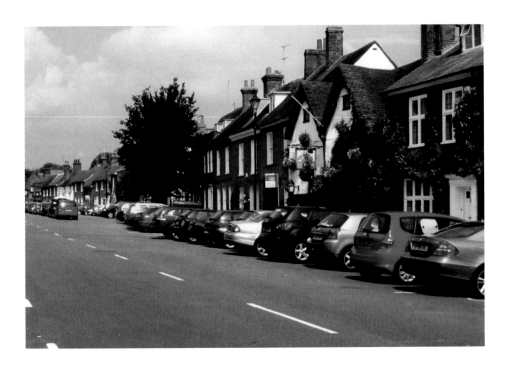

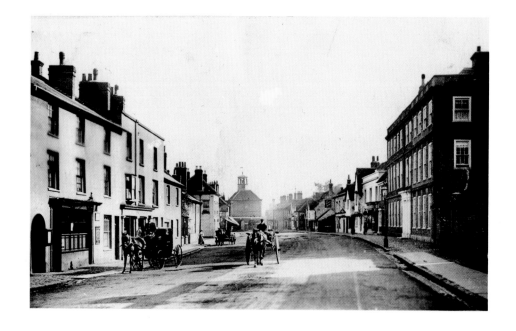

The Post Office

Amersham post office is at the left of this 1905 postcard, with a mail coach standing outside. The arch at the edge of the building gave access to the post office yard and the sorting and delivery offices. The second view, a few years later, shows the front of the post office in more detail. After a hundred years here it was reduced to a sub-office in 1931 when the new office in Amersham-on-the-Hill became the main office for the district.

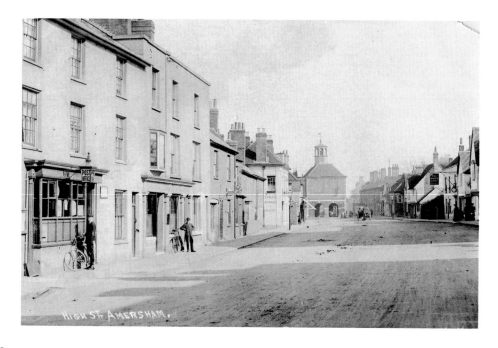

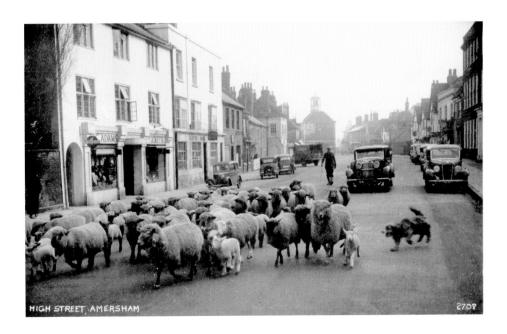

HIGH STREET, AMERSHAM 2709

The Post Office

After downgrading, the old office moved to smaller premises a few doors to the right, beyond Lloyds Bank. The old building was then modernised with new shop fronts, pictured in the early '30s with a flock of sheep making their leisurely way along the High Street, oblivious of the traffic. Later the post office moved into a shop in Market Square, only to become one of the many branches closed down in the purge of 2008.

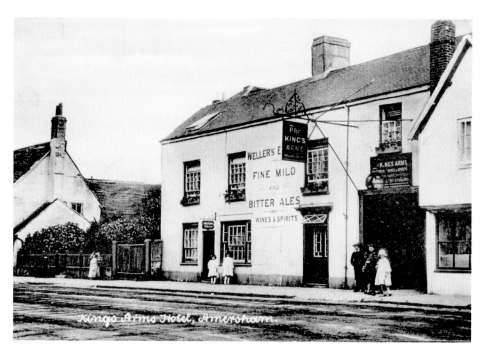

The King Arms

Now the most traditionally picturesque of Amersham's many inns is the Kings Arms. The building began life as a small country inn and adjacent cottages of fifteenth- and sixteenth-century origin. The roofline was altered and the front rebuilt and rendered two centuries ago, giving it the plain appearance in the first postcard of about 1905. A companion postcard shows the hotel's yard where coach horses were fed and watered or changed.

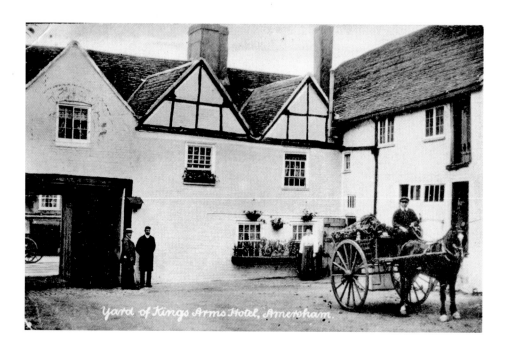

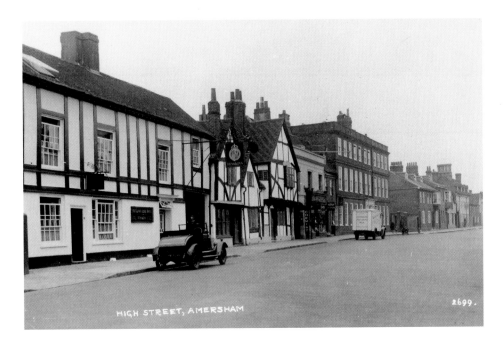

The King Arms

In 1930, in common with many other public houses nationwide, the Kings Arms was given crude fake timbering, seen on the postcard of the High Street published a few years later. The adjoining timber-framed house was incorporated into the building in 1936 and the whole of the original inn's frontage was rebuilt to match, with additional gables, as seen in the modern view.

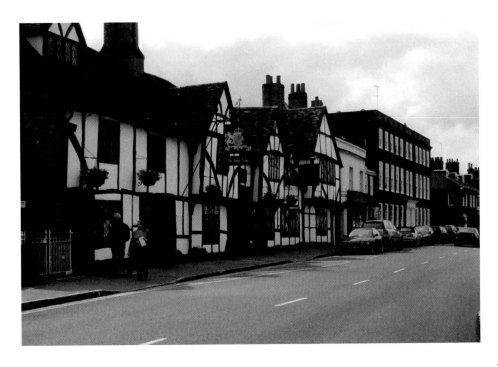

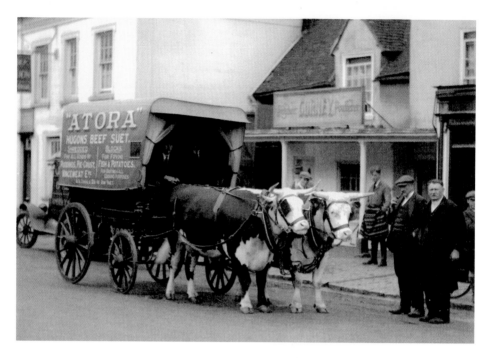

Gurney's Shop

John Gurney opened his High Street butcher's shop here in about 1900. Pictured in 1918, the Atora cart, pulled by two pedigree Hereford bullocks named Dumpling and Pudding, called here on part of a two-year publicity trek around England during which they walked some two thousand miles. The butcher's remained here until the '30s, and the seventeenth-century building, named Buckingham's Gate, later reverted to residential use.

Climpson's Shop

Climpsons took over the shoe shop here in 1929 and this postcard (unfortunately damaged in the ensuing eighty years) was issued to show their saddlery and leather goods shop near the town hall. Here, one could also find a selection of clothing, plus boots and shoes made on the premises. Eventually, after many years of selling footwear, the shop became one of Amersham's many antiques dealers but now sells fashion wear.

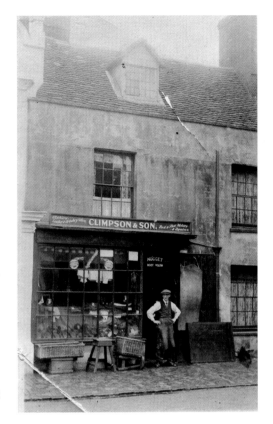

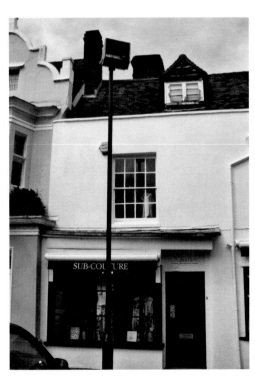

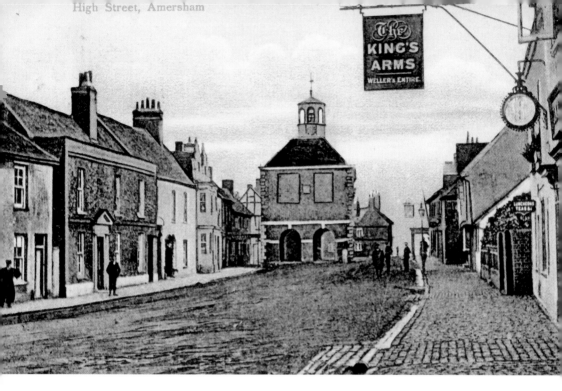

The Town Hall
Built in 1682 at the expense of the squire, Amersham's market hall or, as it is commonly known, Town Hall, comprised a meeting room above an open arcaded market area. The first picture depicts the dreadful state of the road in 1905, the second (1915) shows a scout band leading a group of locally-billeted soldiers on the start of a route march.

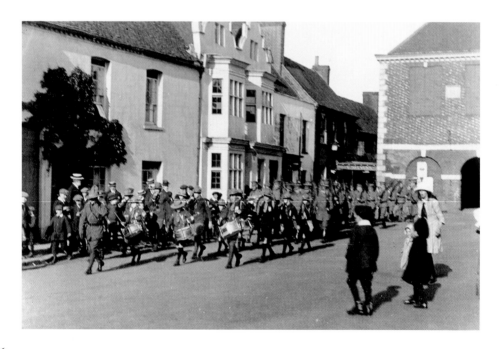

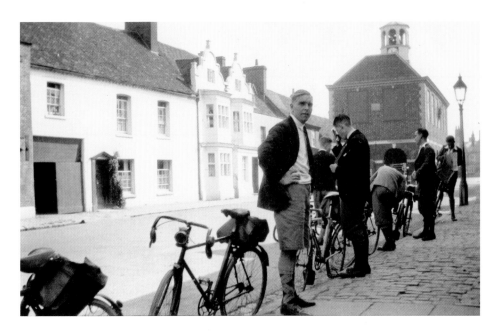

The Town Hall

In the mid-1930s touring by cycle was very popular, and a group of cyclists has stopped for a breather on the pavement near the Kings Arms. Today's photograph is dominated by traffic, either parked in the wide street or squeezing past the town hall, and the view is temporarily spoilt by the protective cover over the damaged roof of Church House, clearly visible to the left of the town hall.

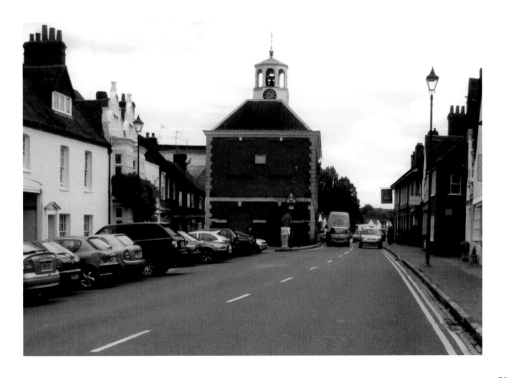

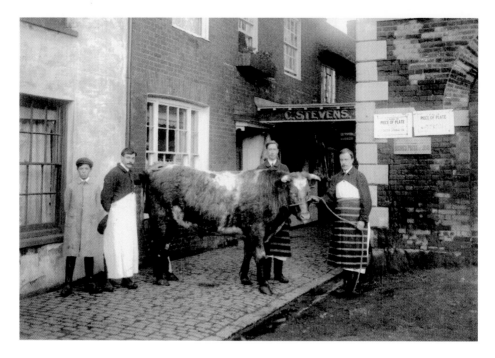

Stevens' Shop

Stevens' butcher's shop was entered from the narrow passageway beside the town hall, and in this 1912 photo the butchers are proudly showing off the prize bull they had purchased. In about 1910 Cornelius Stevens had taken over the business from William Dumbarton, a farmer at Woodrow, Stevens and Sons continued in business here until the 1960s after which the shop with its extensive back rooms was converted into Market Walk, an arcade of small boutiques.

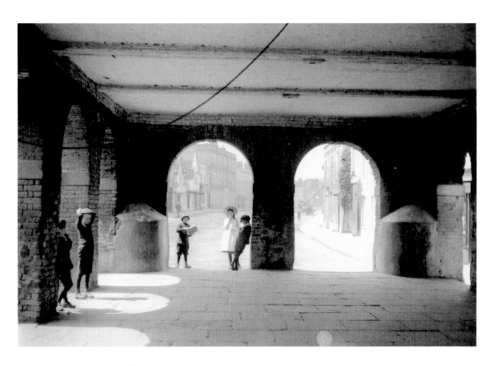

Town Hall Undercroft

The open area under the town hall was originally used for the traditional Amersham market. When pictured, in the early years of the twentieth century, both arches on the west side were open, giving views of the High Street. As part of a major refurbishment of the hall in 1912, a second staircase was built in order to give safer access to and from the upstairs meeting room. This rose inside the right-hand arch, which was bricked up as seen in today's photograph.

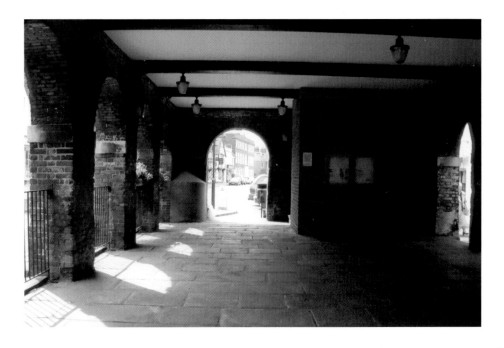

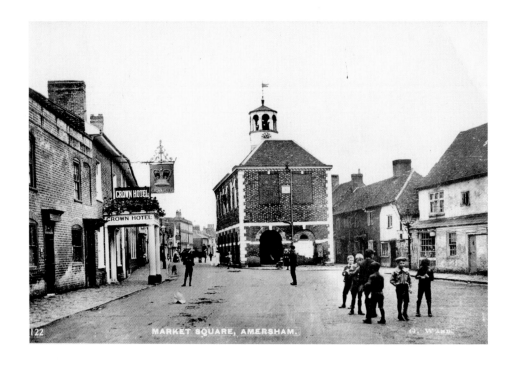

Market Square

The first postcard of Market Square dates from about 1910, when youngsters could safely play in the middle of the road. In the '20s, although a lorry can be seen beyond the town hall, traffic was still light enough for two girls to stroll in the wide road.

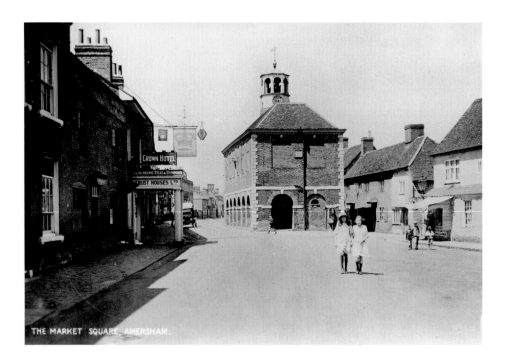

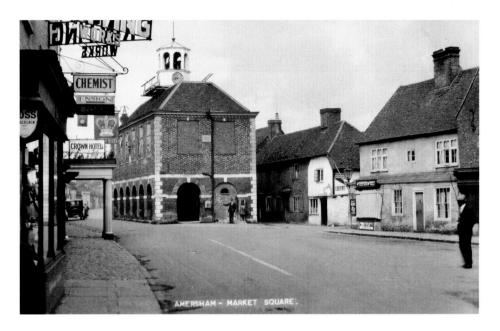

Market Square

On an unusually quiet day in 1930, a scaffolding platform had been erected on top of the town hall for work on the clock. The four faces of the clock can be seen over the rooftops from almost anywhere in the town and at one time the managers of the brewery asked for the north face to be covered to prevent their employees from clock-watching. At the right-hand edge of today's view, the north side of the square is still shrouded in scaffolding following 2008's serious fire.

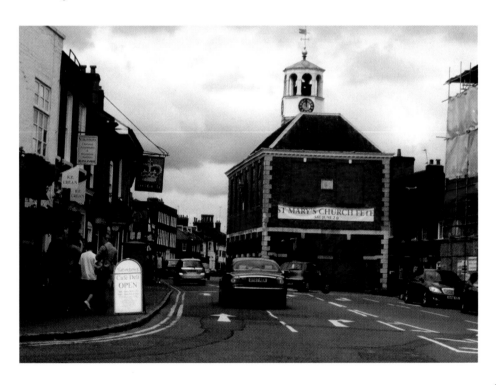

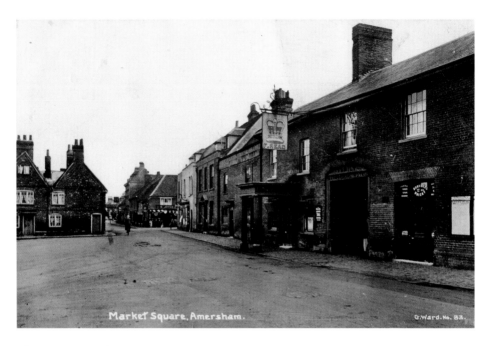

Market Square, Amersham.

G. Ward. No. 83.

The Crown Hotel

Pictured in about 1910, Market Square then was a real square, with buildings on all four sides, the Crown Hotel occupied most of the south side, with its carriage arch beside the entrance porch. The stagecoach service through Amersham had ceased when the railway reached the area, but was revived later as a tourist attraction, operating between Great Missenden and Windsor via Amersham. It is pictured here outside the Crown Hotel on a misty day in the early '20s.

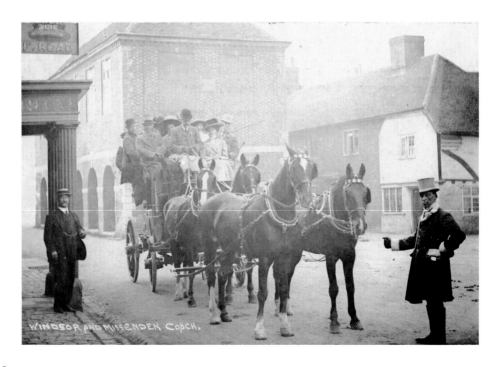

WINDSOR AND MISSENDEN COACH.

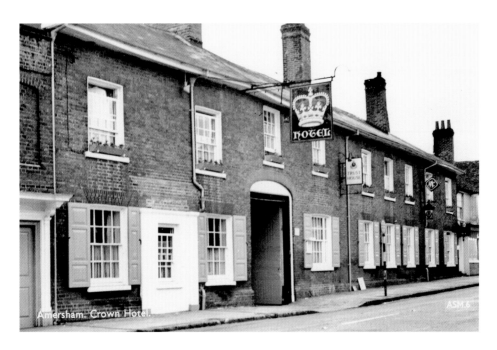

The Crown Hotel

The Crown's pillared Georgian porch had extended to the edge of the pavement, unfortunately too close to passing traffic and after a succession of encounters with vehicles, was removed in 1960. The entrance was moved to within the carriage arch and this postcard includes the window newly installed in its place. Today's photograph shows the frontage, unaltered in the past fifty years.

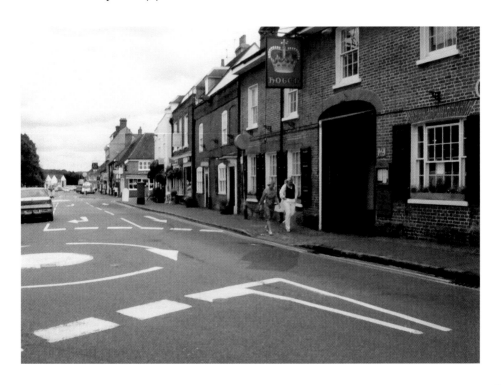

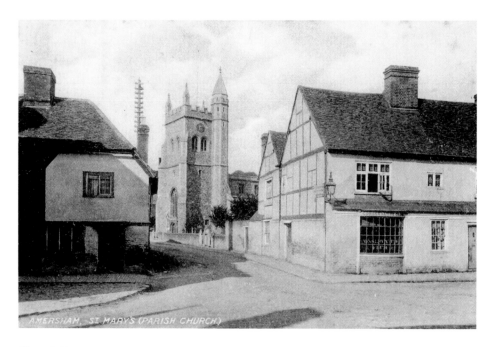

Church Street

This view of Church Street is the most photographed and painted scene in Amersham, reproduced on over a hundred different postcards over the years, during which time it has changed only slightly, as depicted by this series of views. Seen in 1900, since 1890 the right-hand corner property had housed Amersham Conservative Club. By 1910 the bracketed gas lamp had been replaced by a lamp post at the corner, beside the barber's pole announcing Wilson's shop, and a new window looked onto Church Street.

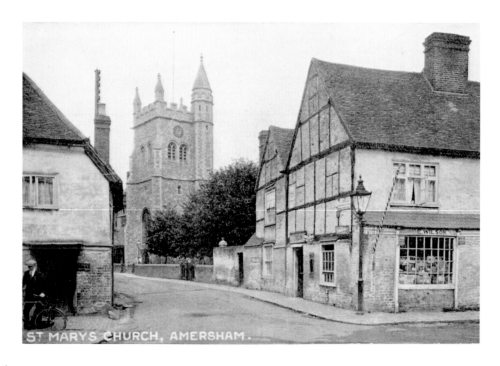

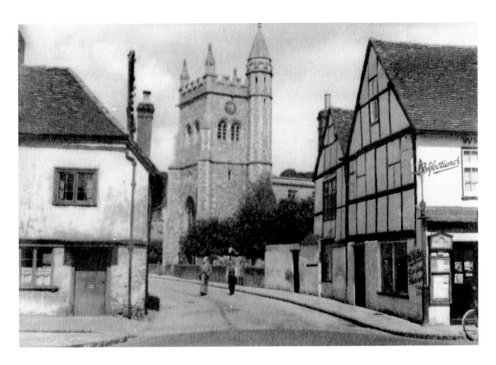

Church Street

In 1935, without the hairdresser, Mrs H. Wilson ran the business, which had been given a new doorway directly onto Market Square. After a series of other uses and rebuilt shop fronts, the building was restored at the end of the century with smart bricks replacing the old rendered infilling between the timbers. After the 2008 fire the resultant rebuilding work is slowly restoring it to its previous appearance.

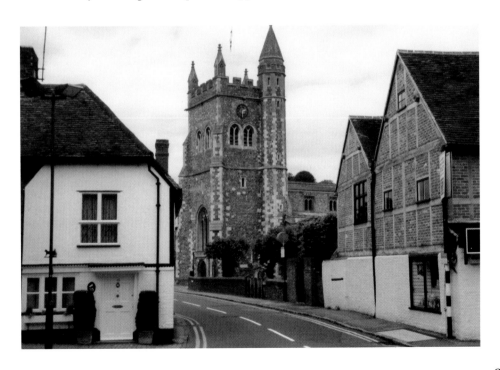

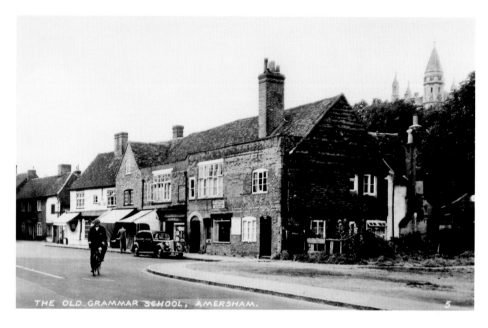

THE OLD GRAMMAR SCHOOL, AMERSHAM.

The Church House

The former Church House is pictured here in about 1940. Part of the building was once used as a workhouse, then Doctor Challoner's Grammar School was established here in 1624, moving up the hill in 1905. For many years until the seventies, the Willow Tree Café, beside the church path, served really home-made refreshments in an old-world setting. The building had changed little until a disastrous fire in 2008 destroyed much of the roof and it is still undergoing major restoration,

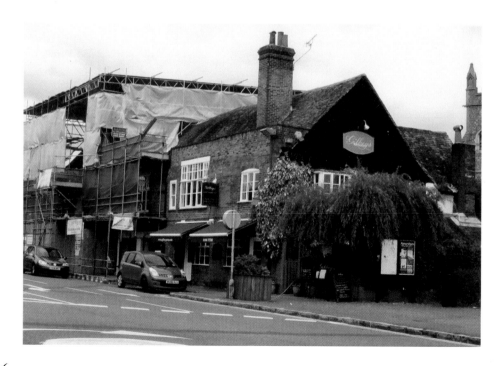

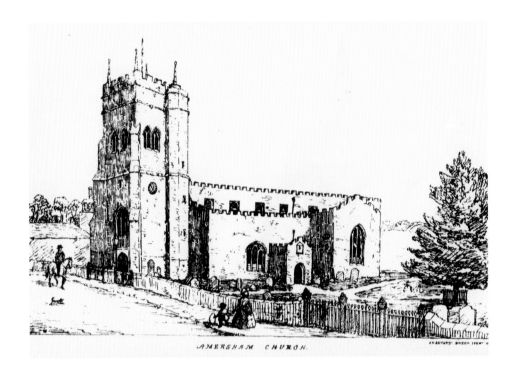

AMERSHAM CHURCH.

St Mary's Parish Church

Amersham church dates from the thirteenth to the eighteenth centuries, but was 'restored' by the Victorians. The drawing shows the external appearance before the 1880s, when the tower was reshaped with the now familiar turret at the top of the corner staircase. Flints from the excavations for the new railway line, were used to give it the traditional local facing of knapped flints instead of the previous roughcast. The 1940s postcard shows the view from about the same point, which remains unchanged today.

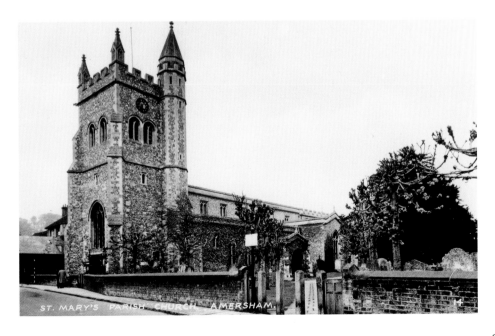

ST. MARY'S PARISH CHURCH, AMERSHAM.

27

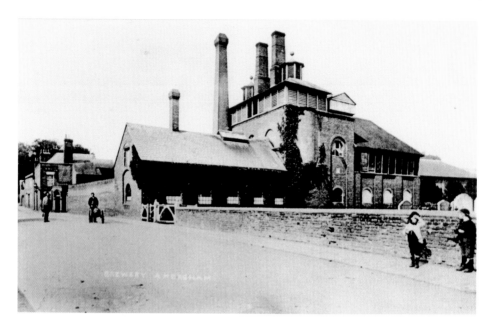

Amersham Brewery

Pictured in 1890, the Amersham Brewery was already a hundred years old when the Weller family bought it in 1775. Over the next 150 years they acquired most of the local public houses to a final total of 133. The town's largest employer, in 1929 they sold out to Benskins, who closed the brewery and supplied the tied houses with their own brews. The buildings were later used by the Goya toiletries company, and have recently been converted into flats.

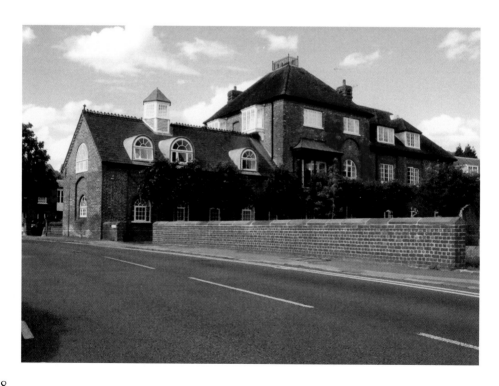

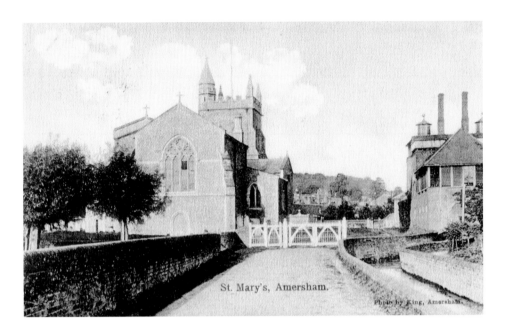

St. Mary's, Amersham.

Photo by King, Amersham.

Church and Brewery

The Misbourne here flows in a well-defined channel between the church and the brewery in 1905, but in the fifteenth century it had presented a flooding threat to the church and the floor level of the church was raised by four feet. The flow is now reduced to little more than a trickle and is sometimes non-existent for months on end. Trees now hide the old brewery from this direction, and its new residents have been given added privacy by the high brick wall on the bank of the stream.

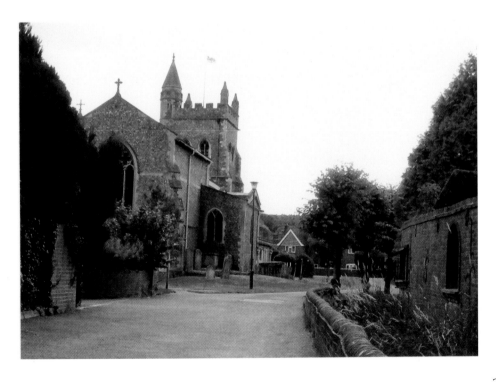

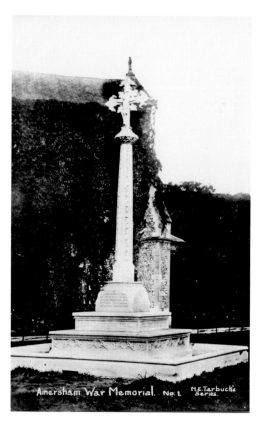

Amersham War Memorial. No. 1. M.E.Tarbuck's Series.

War Memorial

The photographic postcard, published by a local greengrocer in about 1920, shows the 1914-1918 war memorial in its original position in the churchyard near to the corner of the chancel. By popular request the memorial was moved to a more prominent position in the 1949 garden of remembrance and the colour photo shows its former site, used in the 1990s as a rose bed, though now turfed over.

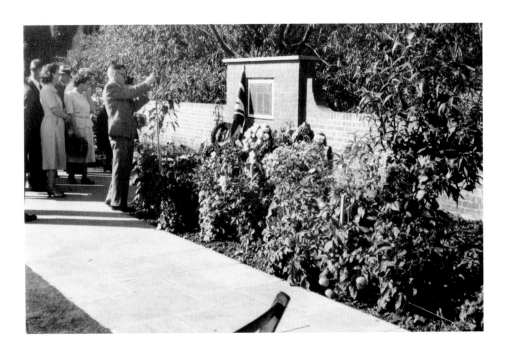

War Memorial

Amersham's garden of remembrance was opened alongside the churchyard in 1949 with a plaque commemorating the local men and women lost in the 1939-1945 war and the upper photo shows the plaque during the dedication ceremony. The modern photograph is of the original war memorial in its new position, flanked by hedges at the end of the garden.

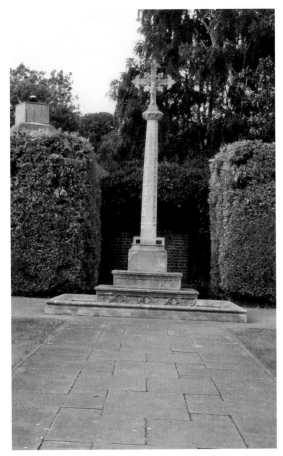

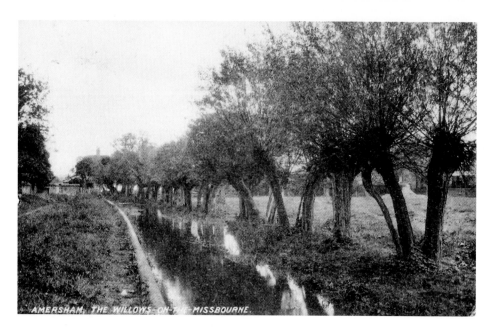

AMERSHAM, THE WILLOWS-ON-THE-MISSBOURNE.

River Misbourne and the Gasworks

Past the brewery the Misbourne flows between a solid wall and a willow-lined bank behind the north side of Broadway. The Amersham Gas Light and Coke Company opened their gasworks off Broadway in 1855, initially with small unobtrusive gas-holders and the manager's house beside the river. Two large holders were added by the 1940s, dominating views from the adjacent hill and, as pictured in 1983, from the riverbank near the church. To the relief of local residents, all was removed in 1994.

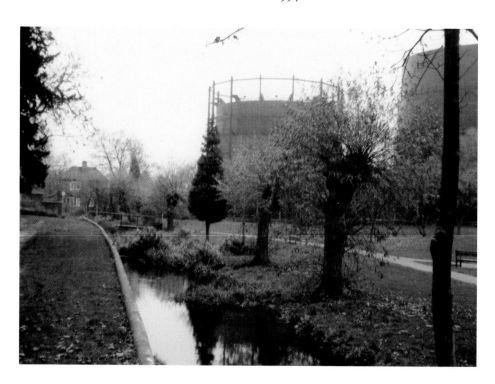

Church Alley

Looking east along Church Alley in 1931, the left-hand block of cottages, Church Row, continued the line of buildings from the Willow Tree to the old Malt House in Broadway, while Middle Row, on the right, was entirely within the road width of Market Square and Broadway, restricting traffic there. After the demolition of the cottages in 1939 the land on the left was incorporated in the garden of remembrance, and the remainder into widening the pavement and roadway.

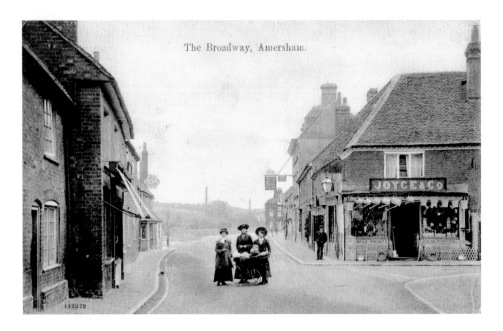

The Broadway, Amersham.

Broadway from Market Square

At the beginning of the twentieth century it was safe to stand and gossip in the middle of the road at the foot of Whielden Street where sun-blinds protected the displays in the south-facing windows of Whiteside's bakery. Although the card is entitled 'The Broadway' very little of it could then be seen from this corner. Now, without Middle Row, most of Broadway is visible, but as today's photo was taken from the safety of the pavement, the top of the tall Griffin Hotel is hidden by the roof of the corner shop.

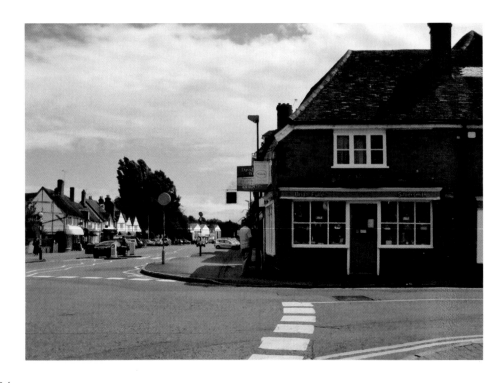

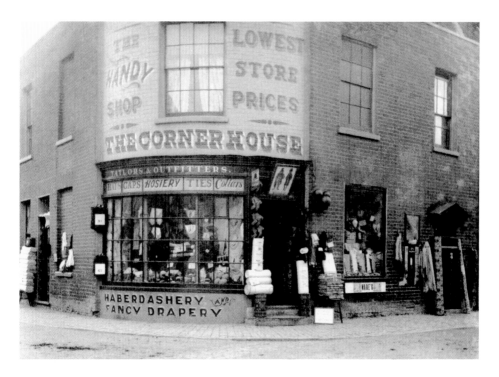

Whieldon Corner

Pictured in 1890, the Corner House was occupied by Wades' haberdashery. Examples of their advertised 'lowest store prices' include vests at one shilling and a halfpenny, and pants at one and threepence halfpenny, also army shirts at half-a-crown. From about 1905 the premises were used by the Union of London and Smiths Bank who, with their successors for the rest of the century, later rebuilt the corner as three narrow entrances. This unusual frontage has been retained by subsequent occupiers of the premises.

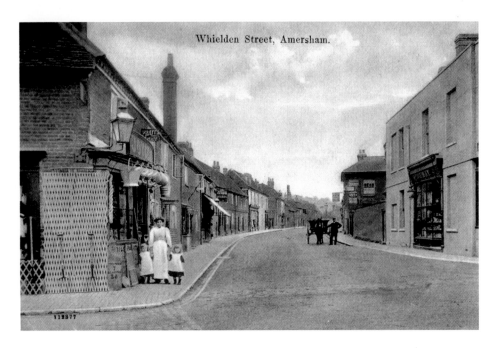

Whielden Street, Amersham.

Whieldon Street

Viewed from the High Street in about 1900, the terraced cottages on the left included the barber's shop, identified by the traditional striped pole outside, and next door to him was a small general store and then the Hare and Hounds. The detached building opposite the Hare and Hounds was shared by Toovey's bakery and another inn, The Nag's Head. The barber's shop is still trading as such, but the Hare and Hounds closed in the '40s and The Nag's Head twenty years later.

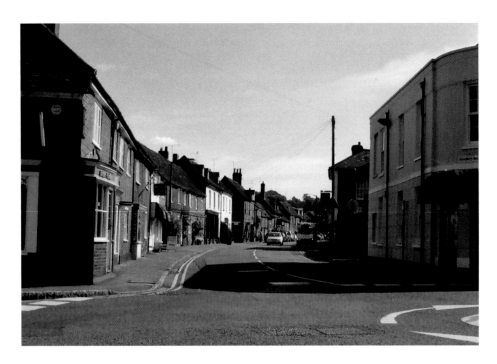

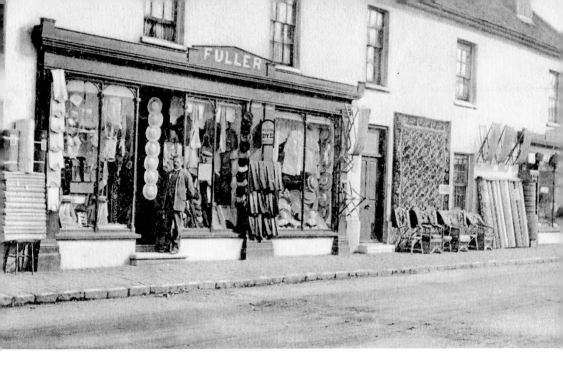

Fuller's Drapery

In the middle of Whielden Street, Fuller's 'Emporium', as it was generally known in the town, stocked all manner of clothes and household goods. The business had opened here in about 1870 in the former workhouse, in what was then known as Union Street. With later, a second shop in Hill Avenue, Fullers remained here until 1950 when the main part of the building became an agricultural goods supplier, later one of Amersham's many antique shops, and now a kitchen design business.

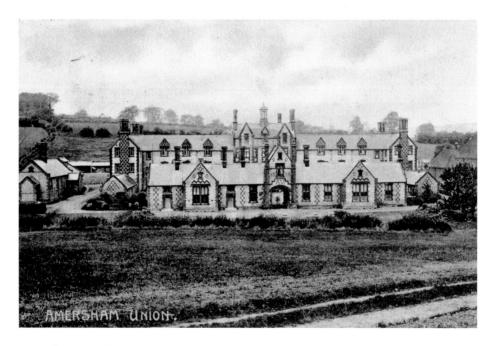

Amersham Workhouse

Designed by the famous architect George Gilbert Scott, the workhouse of the Amersham Union of Parishes is pictured in about 1900. The workhouse's infirmary was expanded early in the twentieth century and formed the nucleus of 'St Mary's Hospital', The brickwork within the central flint panels announces 'A U 1838', the intended date of opening, which was delayed a year by the bankruptcy of the builders. A century later, the buildings were commandeered by the government as an emergency services hospital, to cope with anticipated air-raid victims locally and as overflow for St Mary's Hospital in Paddington.

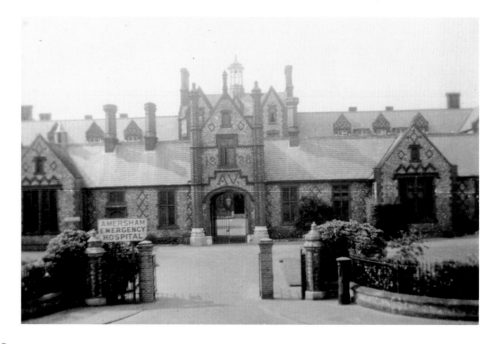

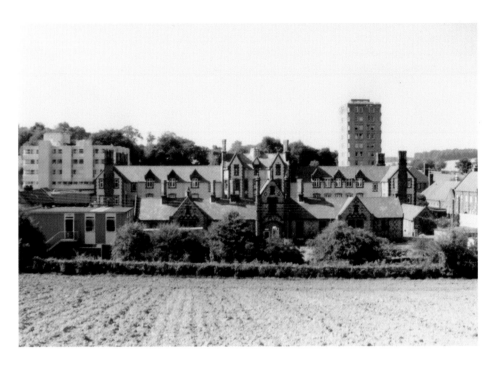

Amersham Workhouse

After the war the NHS took it over as the local general hospital and erected more buildings including an unsightly tower block as a nurses home, seen in 1981. Later changes have seen more new buildings and removal of the eyesore. Following the recent closure of most of the wards and services, and removal of others to the adjacent new buildings, the old workhouse has now been converted into apartments.

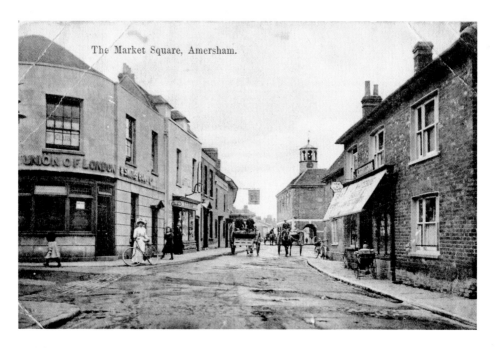

The Market Square, Amersham.

Middle Row and Market Square

This hundred-year-old postcard shows Market Square, looking past Middle Row. Behind the sun-blinds was Whiteside's bakery, part of which was in the rear block, Church Row, making it necessary to carry produce across the intervening Church Alley. As with most of the town's traders, he provided a local delivery service by horse-drawn cart. Since the demolition of Middle Row, there has been a much wider view into Market Square, a view now suffering from the after-effects of the 2008 fire.

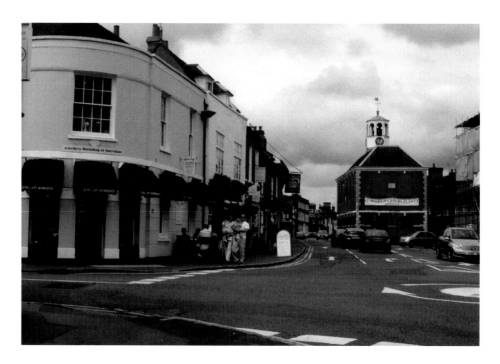

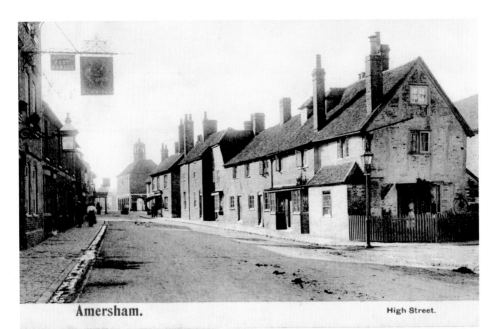

Amersham. High Street.

Middle Row, 1900

All of Middle Row is seen in this 1900 view from Broadway through to Market Square. Mrs Dobson's house, at this end, was the only one in the two blocks with any garden, a little area facing the widest part of Broadway. The gap between the buildings further along was a narrow passage connecting Whielden Street to the church. The trees in Amersham's garden of remembrance now fill the area in front of the church.

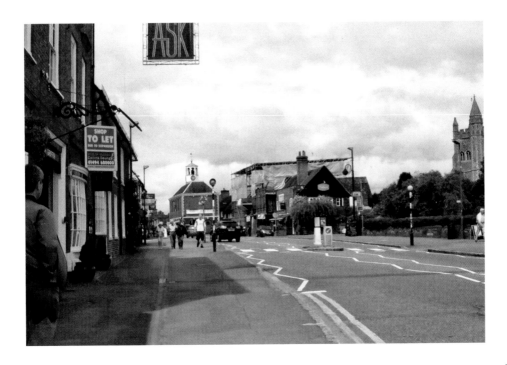

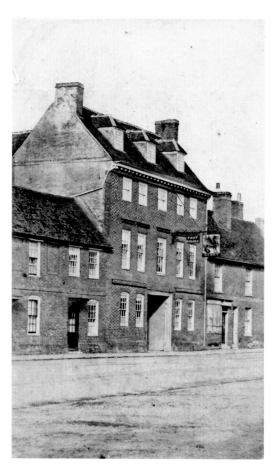

The Griffin Hotel

Pictured in the early '20s, the Griffin Hotel, a former changing post for stagecoaches, with stables and accommodation for drivers around its cobbled courtyard, which later became the first depot for the Amersham & District Bus Company. Their vehicles accessed it via a farm track from Whielden Street as the coach arch was too small for them. In the second picture, a decade later, the Old Berkeley Hunt is assembling in the wide road in front of the hotel.

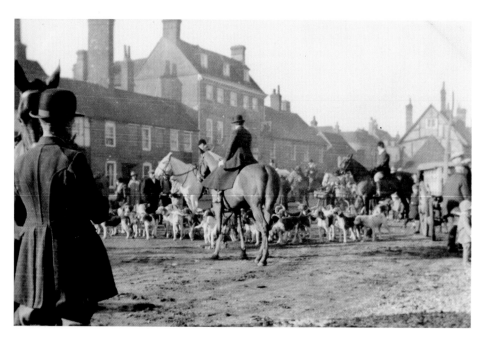

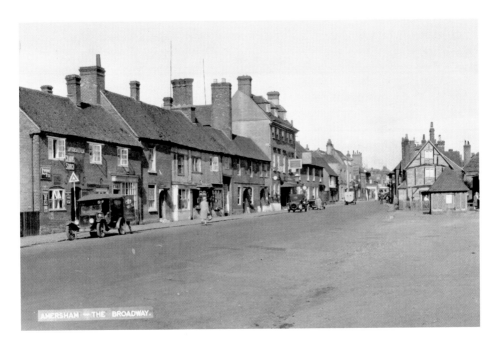

The Griffin Hotel

A view from later in the '30s includes a car filling at Amersham's first petrol pump on the pavement outside the Griffin, which then offered full garage facilities to visiting motorists. In today's view, without Middle Row, Broadway has really become broad for all its length.

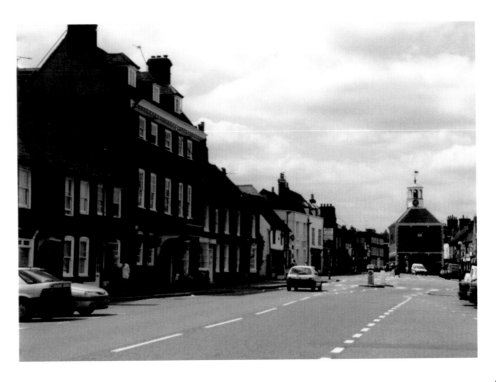

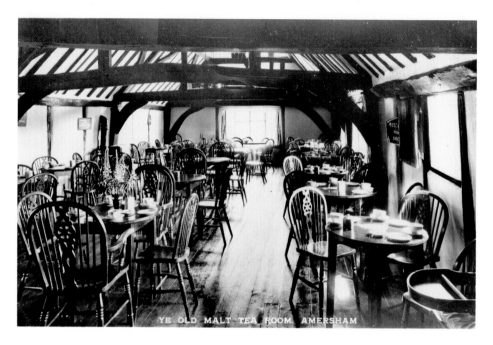

The Old Malt House

Pictured in about 1935 set for afternoon tea, Ye Old Malt Tea House served refreshments from 1930 until well into the '60s in this beamed dining room upstairs in the fifteenth-century building which had been one of Amersham's several malthouses. The restaurant was in the rear wing of the building, and its end window looked out over the Misbourne. The second view, published in the '50s, shows the front of the building, including the restaurant and its immediate neighbours.

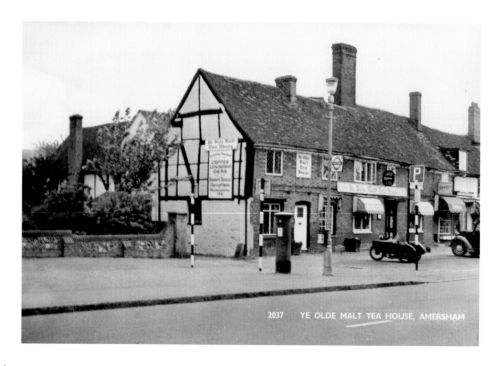

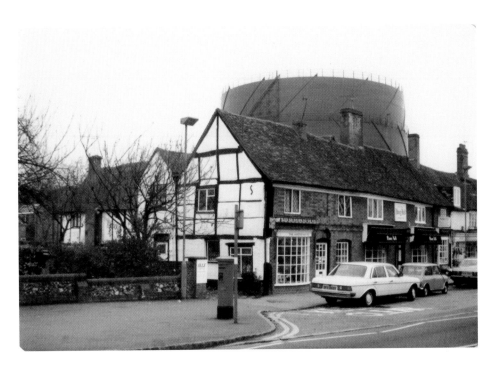

The Old Malt House

An unsightly gas-holder was built in the adjacent gasworks in the 1940s, and from then unspoilt photographs were only possible when gas pressure was low and the top of the holder had sunk behind the buildings. The third picture (1983) shows it at its worst, completely full. The gasworks was removed ten years later and today's view of the shops which now occupy all the old building is only spoilt by cars parked in front.

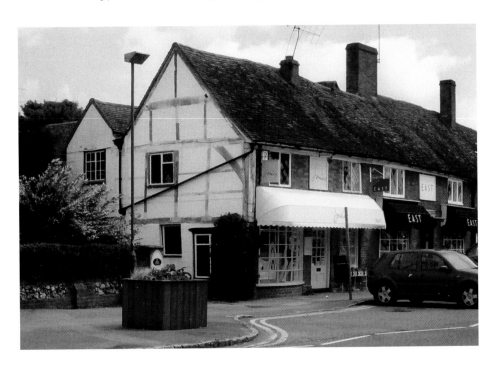

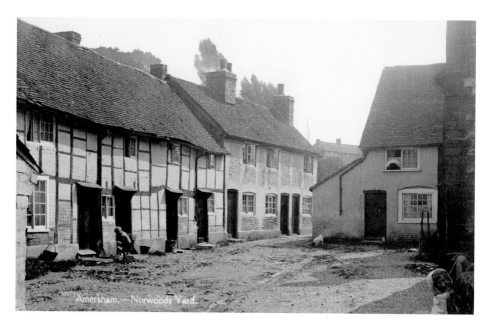

Amersham.—Norwoods Yard.

Norwood's Yard

From the seventeenth century Amersham was an important centre for the production of leather, with several tanners and curriers taking advantage of the water of the Misbourne. A hundred years later, Richard Norwood owned two of the tanyards, and his employees lived in Norwood's Yard, this terrace of small cottages off Broadway, pictured in 1930. Replaced in the following decade by a small group of detached houses, now hiding behind a colourful hedge, this was later given the more up-market name of Norwood's Court.

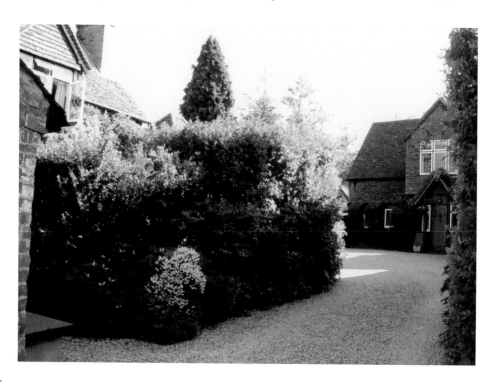

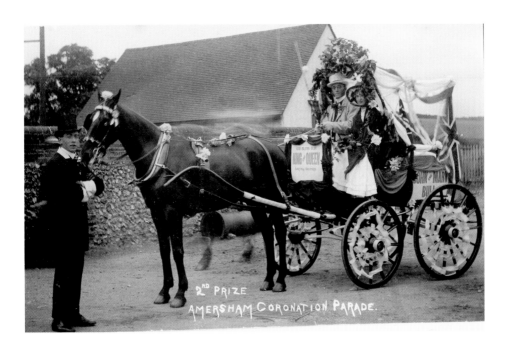

The Fire Station

Taken primarily to show the prize-winning carriage standing in front of it, this photo includes Amersham's fire engine station in Broadway beside the entrance to the gasworks. At that date the town was still protected by an elderly manually-pumped, horse-drawn fire engine using the horses from Wilkins' coal delivery cart. This fire station was superseded by a new one on the hill in the '50s and the entrance to Dovecote Meadow car park was created through the site of the old.

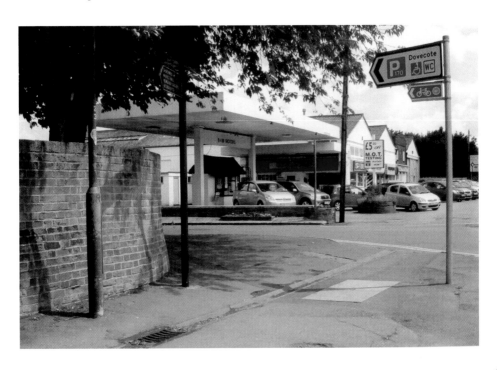

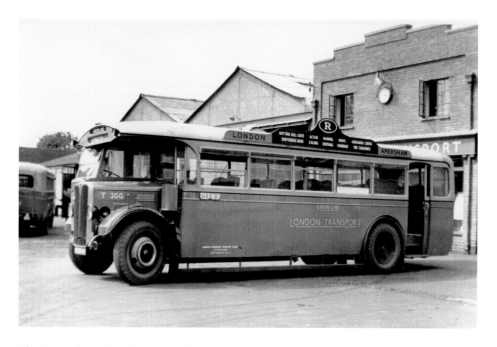

The Amersham Bus Company Garage

The Amersham & District Omnibus & Cartage Company was formed in 1919 by a group of local businessmen, initially with two buses working out of the Griffin Hotel yard on a route from Chesham to High Wycombe. They soon expanded with more vehicles on several local routes and built this depot in Broadway. The photo dates from the '30s, just after the company was taken over by London Transport. The garage is now used by a local car dealership.

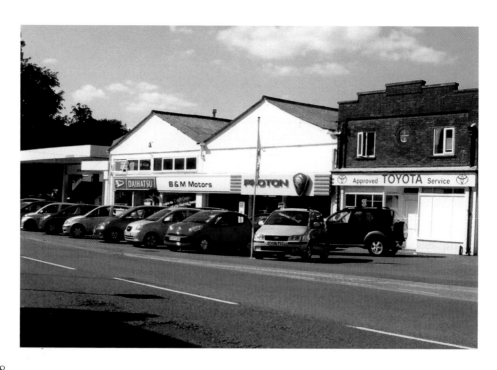

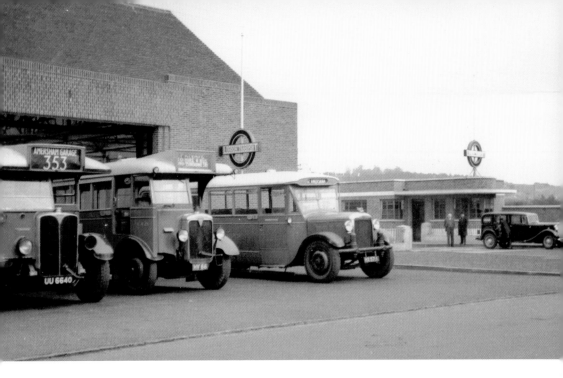

London Transport Garage

In 1935 London Transport opened a new garage with capacity for fifty-four buses, alongside the old A&D building, which was retained for several years for overflow parking. The new garage is pictured soon after opening with three buses on the forecourt. The wing to the right of the view, beyond the service road to the rear of the garage, housed enquiry and other offices. All was demolished in 1989 when Tesco acquired the site for their petrol station, now well screened from the road by dense foliage.

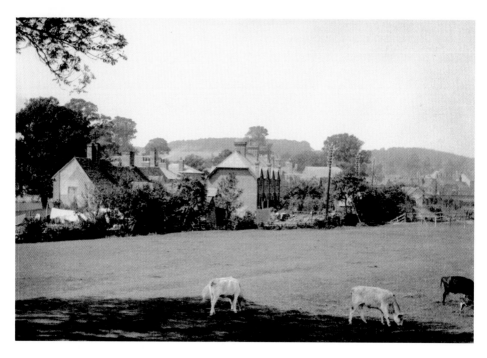

Wilkins' Meadow

Wilkins' Meadow, in the angle between Bury End and Station Road, was named after the local coal merchant who released his horses there when not required for pulling the coal cart or hauling the manual fire engine. In 1931 the Brazil family expanded their meat processing business into a purpose-built factory on the meadow. Later taken over by Bowyers, the business moved out of the district in 1986 and the site was cleared in the early 1990s for a supermarket and its extensive car park.

Station Road Bridge

At the foot of the hill, Station Road crossed the Misbourne by this bridge, pictured early in the twentieth century. Wilkins' Meadow, to the left, was barely above water level when the stream was full and a deep hollow remained where the water turned under the bridge. Around 1930 the bridge was rebuilt, the hollow filled and the ground level of the meadow raised to accommodate Brazil's factory. The modern photo shows the bridge in the 1990s before Tesco developed the site.

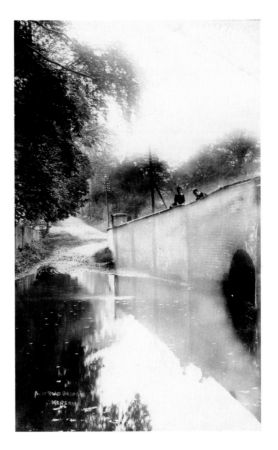

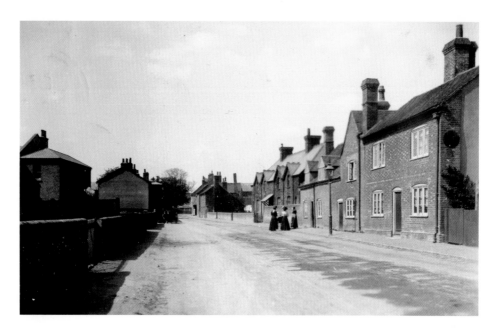

Bury End

Along London Road, Bury End was a self-contained community, once considered separate from Amersham town. It is seen on this postcard view, looking back toward Broadway. The cottages on the right, which backed on to Wilkins' Meadow, and faced the historic Bury Farm and the waterworks, were all demolished in the '50s or '60s, and the land was later occupied by the supermarket car park. Bury Farm remains, but is now hidden from this direction by trees.

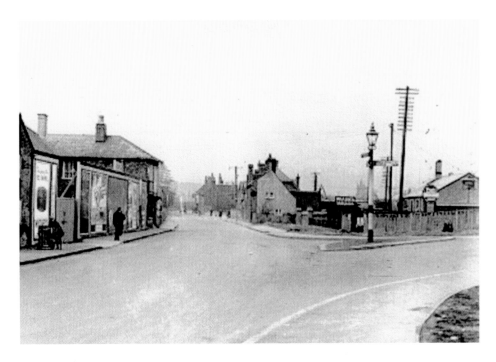

London Road

This 1932 view along the London Road across the foot of Station Road includes, at the right-hand edge, part of Brazil's newly built meat factory, expanding the business started behind their High Street butcher's shop. The cottages of Bury End lined the road into the old town, facing the waterworks and waterworks cottages. Most of the cottages were demolished by the '60s, but the factory was enlarged and modernised, finally giving way to Tesco toward the end of the twentieth century.

Brazil's Factory

Brazil's business continued to grow and a much larger factory was later built near the London Road edge of their site with a separate office block including a retail shop. This photo of the factory was taken in the seventies after the last of the Brazil family had retired from the company and Scot-Bowyers had taken it over. Tesco's store and car park now covers the site, well screened from the road.

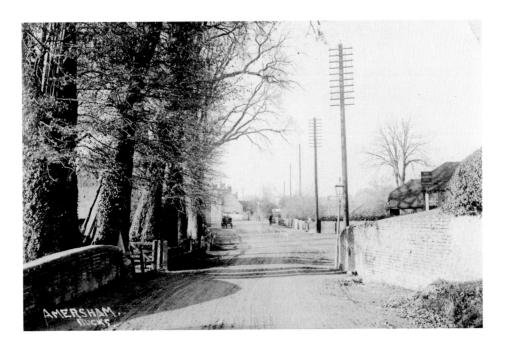

Chequers Hill

Photographed in 1905, the London Road approach to Amersham down Chequers Hill was then lined with magnificent trees, down to the outflow stream from Bury Mill, the end of which can be seen to the right of the road. The trees were later felled, and a petrol station built beside the re-aligned stream on the field opposite the mill. This has subsequently been rebuilt as a car showroom.

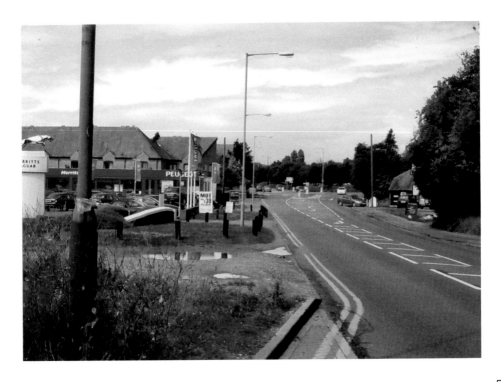

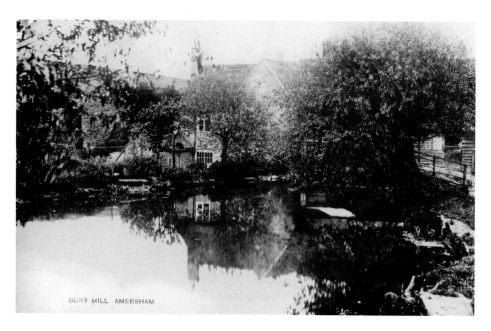

BURY MILL AMERSHAM

Bury Millpond

Immediately after passing under Station Road, the Misbourne fed Bury Mill on the London Road. On this 1900 postcard, photographed from the Station Road bridge, the back of the mill is reflected in the still water of the millpond. Construction of Station Road had caused the closure of the mill as it blocked the mill's bypass channel, resulting in occasional flooding of the mill and the adjacent Chequers Inn. The pond was later filled in and the resultant level area turfed over.

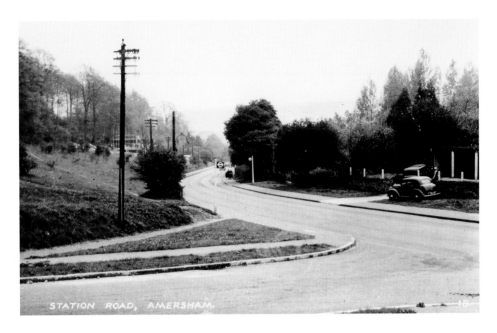

Station Road

Station Road, the main link between the old and new towns, was built by the railway as an easier alternative to the steep Rectory Hill. House building started at the top soon after its opening. By the '20s houses lined much of the road, and in the '30s houses were built on the sloping field below Batchelors Wood, to the left of the view. Recently, several of the houses on both sides of the road have made way for apartment blocks on their large gardens.

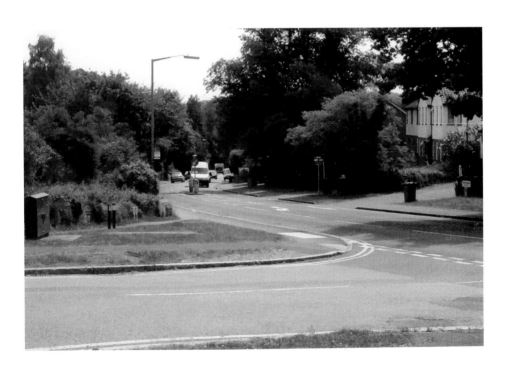

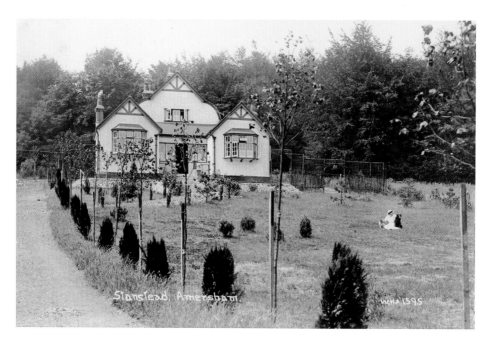

Stanstead

Among the first dwellings of the new Amersham were a few on large plots near the top of Station Road and backing onto Parsonage Wood (or Rectory Wood as it is usually known) on the hillside above the road. One of these new houses, Stanstead, is pictured in 1912, before its drive-side line of conifers had matured. Stanstead itself is now sub-divided, and hidden from the road by a block of flats built on the end of its long garden.

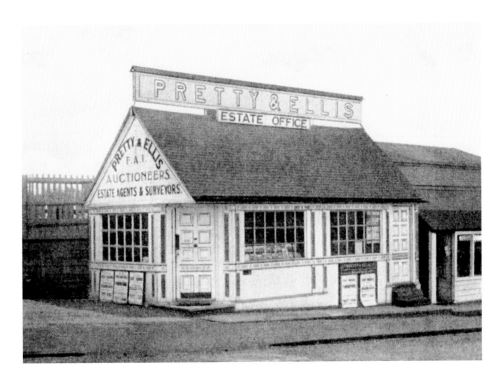

Station Approach

One of the first estate agents to handle properties in the new town was Pretty & Ellis, who opened this temporary office in Station Approach, alongside the station, in the '20s, moving later to permanent premises up the road in Hill Avenue. Although the neighbouring hut remains, now supplying refreshments, Pretty & Ellis's hut was removed in the '50s and the site has recently been filled by a rack for railway passengers' cycles.

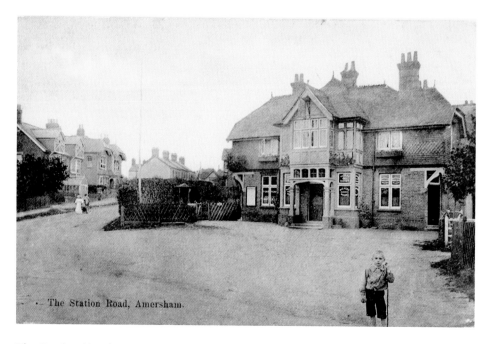

The Station Road, Amersham.

The Station Hotel

Seeking every opportunity to increase their sales, Weller's Brewery opened the Station Hotel, immediately opposite the new station, within a year of the 1892 arrival of the Metropolitan Railway. Pictured here in about 1900, it also provided stabling for those who arrived by horse rather than train. Re-fronted, it was renamed the Iron Horse in the '60s. A block of modern flats has recently replaced the old pub, but it is well hidden by trees at the roadside.

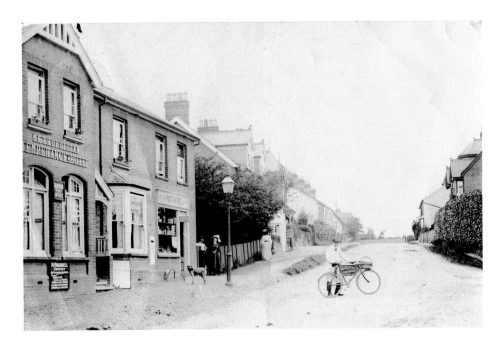

Upper Station Road

To rival the nearby Station Hotel, the Metropolitan Temperance Hotel opened shortly afterwards in the upper part of Station Road, with a confectionery shop and a sub-post office in the same building. This 1910 view also includes the new terraced houses further up the hill. After the closure of the hotel the building had varied uses including offices for the town council but is now a children's bookshop, and the terraced houses have been replaced by blocks of flats.

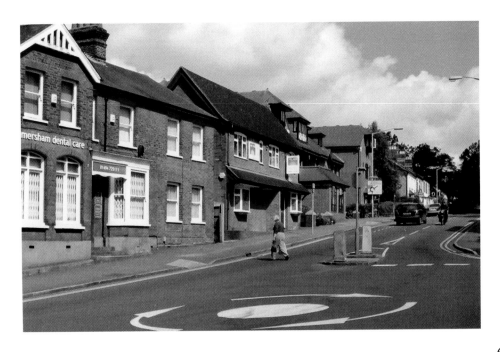

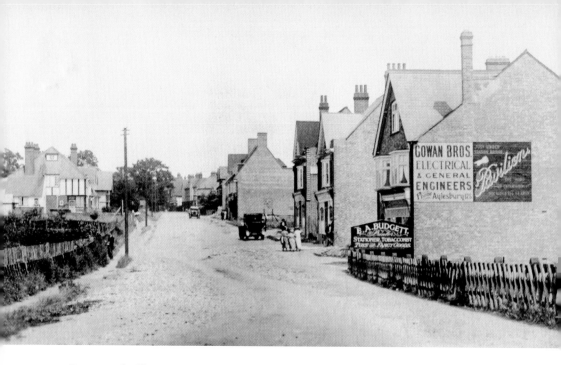

Bottom of Hill Avenue

Pictured in 1923. Hill Avenue, built by the railway, was initially residential, and although forming the main link between the centre of Amersham-on-the-Hill and the station, remained unsurfaced until the mid-1920s. The large puddle in the roadway by the field corner on the left indicates the poor state of the road, but a few shops had been built on the opposite side. Ten years later more shops were spaced at intervals on the right-hand side of the road, with a few huts in the field.

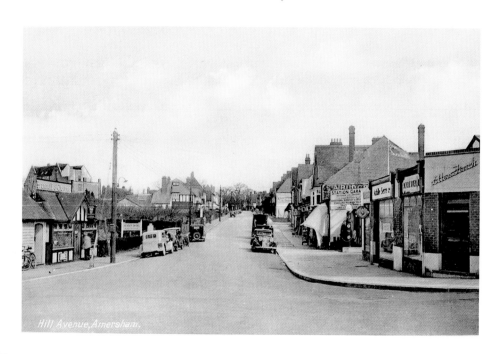

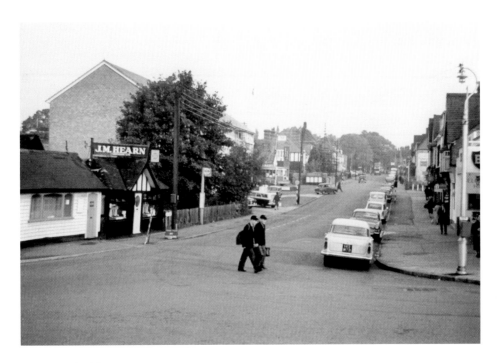

Bottom of Hill Avenue

In 1962 the huts, including a coal order office and an estate agent, remained, but further parades of shops had spread down the hill toward them, surrounding the last remaining houses. Then a further parade of shops occupied the last open space in Hill Avenue, and it now extends around the corner into Station Approach.

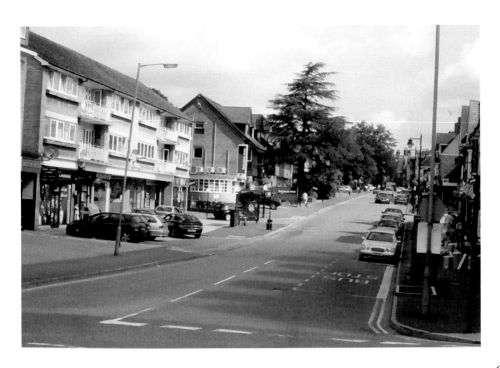

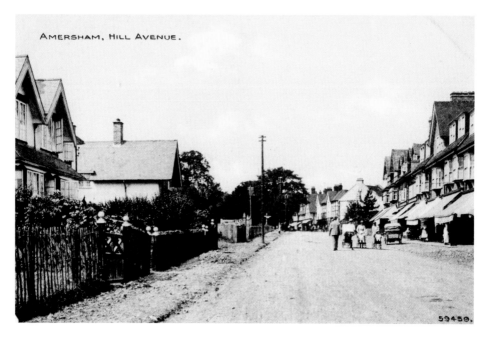

AMERSHAM, HILL AVENUE.

59459.

Top of Hill Avenue

In this view from the early '20s, the new shops near the top of Hill Avenue all protect their windows with canvas sun-blinds and screens, and a very primitive pavement has been laid in front of them. Facing these a detached house and a pair of semis were the only buildings on this side of the road. In 1928, looking downhill, these houses, remnants of the initial scattered residential development in the road, prevented the line of shops from reaching Oakfield Corner.

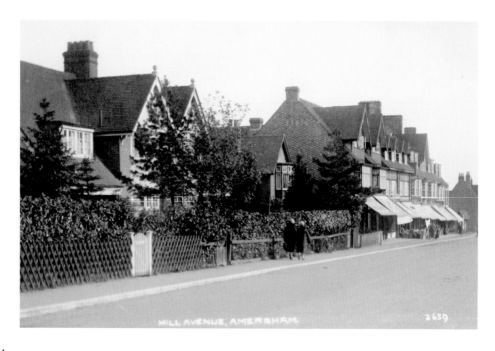

HILL AVENUE, AMERSHAM. 2659

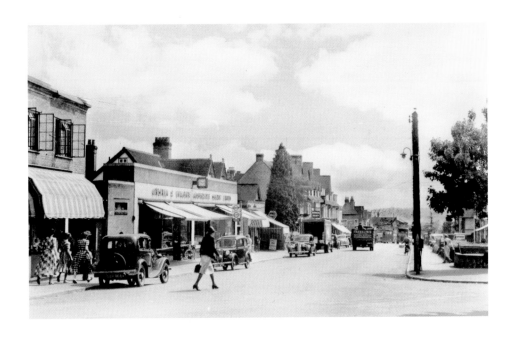

Top of Hill Avenue

Eventually giving in to commercial pressure, the houses were converted into offices, and small shops were grafted onto their frontages, as seen in the middle of this 1935 view from the far side of Oakfield Corner. To their left a branch of the Chesham and Wycombe Co-operative Society had been built in the early '30s at the top of the road. Today the buildings are unchanged but the former Co-op is now a large toy shop.

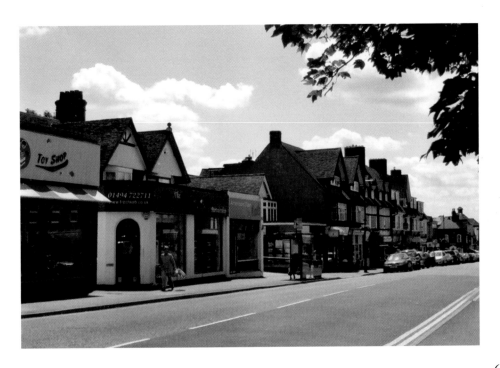

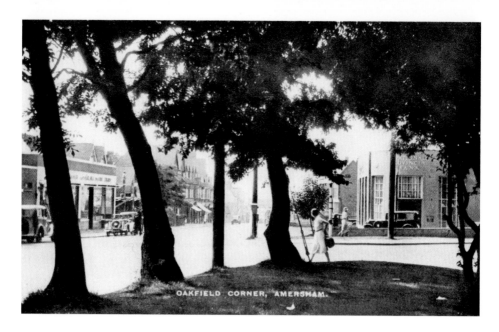

OAKFIELD CORNER, AMERSHAM.

N P Bank

The National Provincial and Union Bank opened its Amersham-on-the-Hill branch in the former chemist's shop on Oakfield Corner soon after the Great War. It is pictured (inset) a year or two later. Under its shortened name it moved to a new building on the opposite corner at the top of Hill Avenue in about 1930, seen between the kerbside trees of Oakfield Corner in the mid-1930s. Today an upper floor has been added to the building, but the rest of the scene has changed very little.

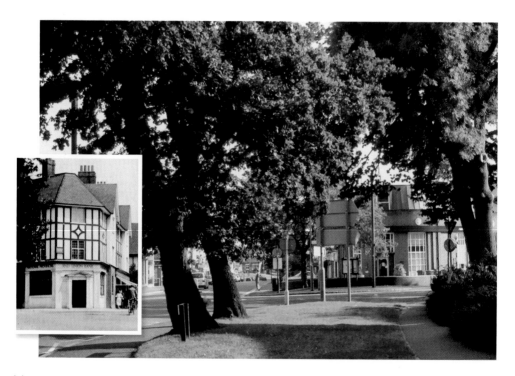

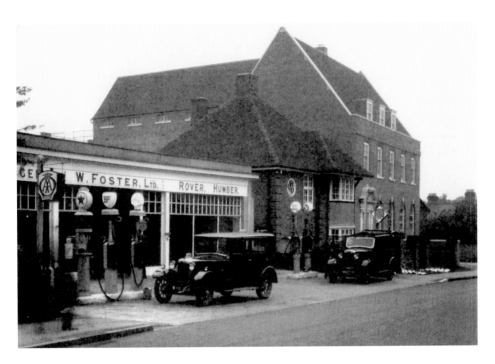

Post Office

A new main post office, replacing that in the old town, opened in Chesham Road in 1930. Photographed that same year, the large building also included the Amersham telephone exchange which took over the whole building when the post office moved in the sixties to Hill Avenue. A private house originally stood between the post office and the garage which William Foster had opened in the mid-1920s, and has now been rebuilt as a new car showroom surmounted by a block of flats.

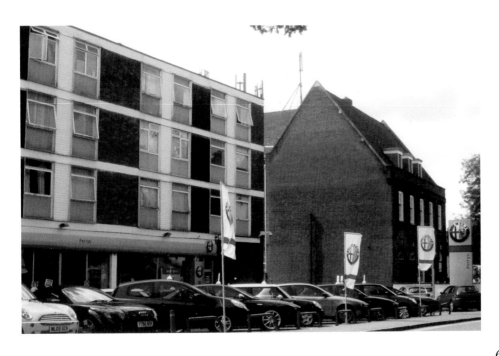

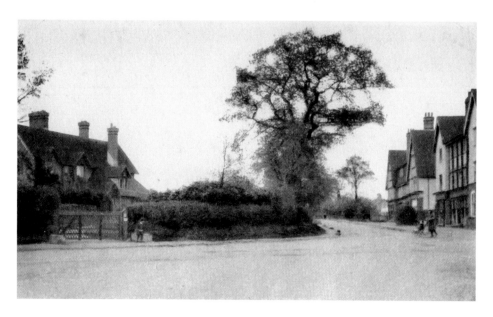

Chesham Road

One of the large oak trees which gave the name to Oakfield Corner remained in 1915, opposite the first shops in Chesham Road. The large house in the angle of the road was, for many years, the home and surgery of a succession of Amersham's doctors. Recently the ground proved more valuable than the house, which has been replaced by a modern block of flats, nearer to the road but still allowing the retention of the roadside trees which had grown out of the original boundary hedge.

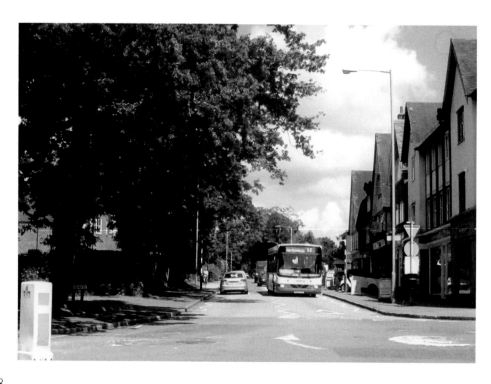

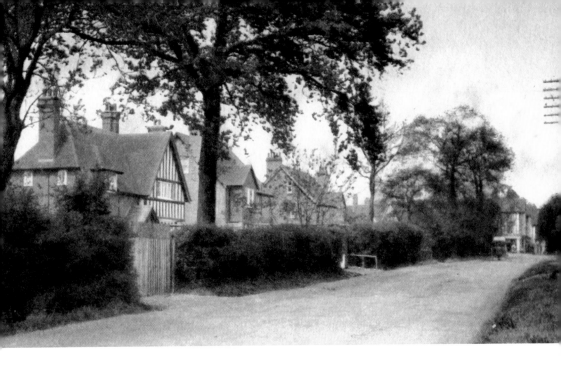

Chesham Road

Once development started on the hilltop common, the main road to Chesham was soon lined on both sides with large houses, some of which are seen on this 1920 view back toward Oakfield Corner. In the last few years most of these houses have been demolished and replaced by blocks of flats or retirement homes.

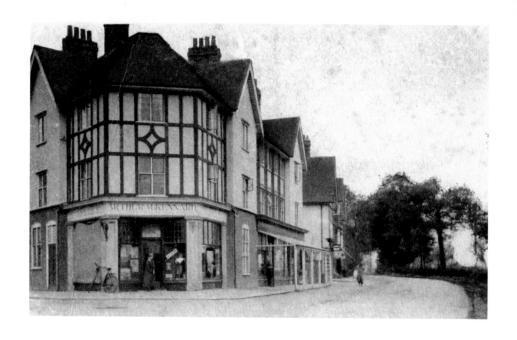

Oakfield Corner

Development of the main shopping centre of New Town started in 1913 with this block at Oakfield Corner. Sycamore Road, ahead, was still bounded on one side by a tree-edged field, but building soon started there, spreading along the road, and with the final development at the far end in the '60s, both sides of the road now offer an unbroken line of shops.

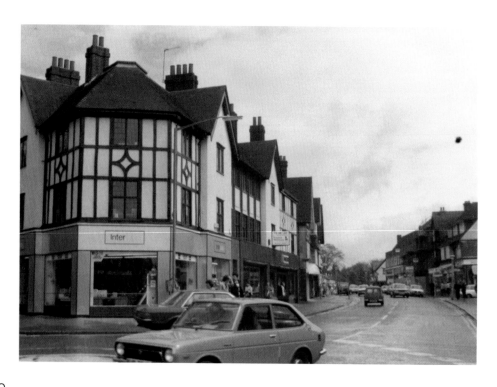

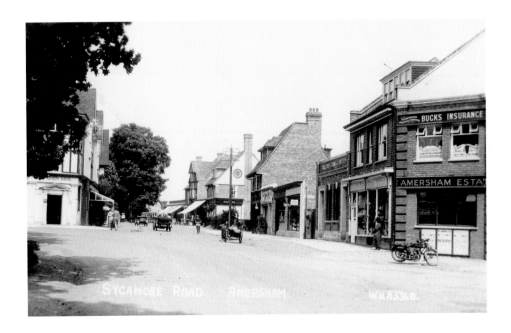

Oakfield Corner

By 1920 a few well-spaced shops stood on the right-hand side of Sycamore Road, some only single-storey, others with the usual accommodation, or offices, above. The Bucks Insurance Bureau, above the estate agents on the corner, issued this card, the back overprinted with their advertisement. Today the gaps have been filled, but several of the original single-storey shops retain their uncompleted appearance.

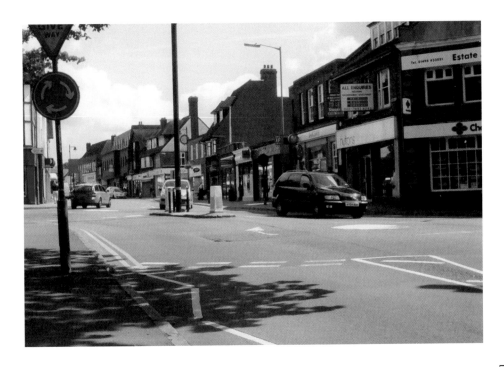

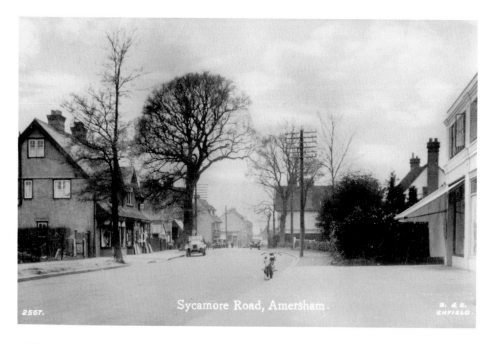

Sycamore Road, Amersham.

2567. B. & S.
ENFIELD.

Chiltern Parade

Looking back toward Oakfield Corner in 1930, Regent Buildings (at the extreme right), built with the cinema, was separated from the rest of the shops by two private houses, 'Ashcot' and 'Romney Cottage', both still fairly new, on large plots behind the trees. In 1937 Sainsburys bought them, and built on the site Chiltern Parade, a smart block of nine shops, with their own store at its centre, flanked by Boots on one side, and Meyers on the other.

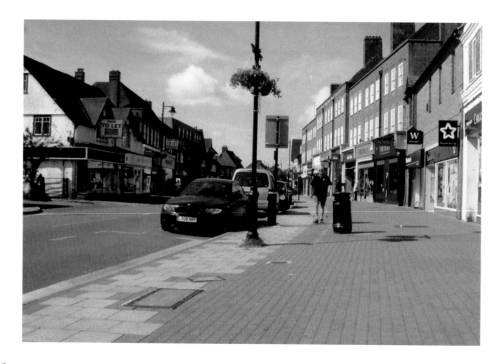

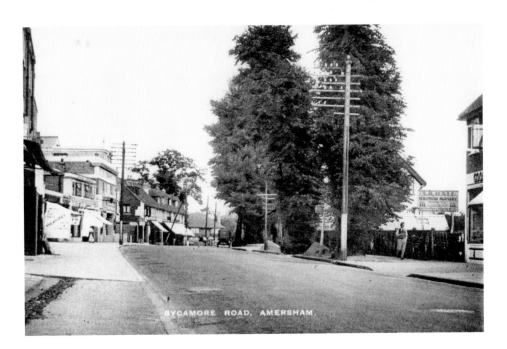

Woolworths

The 1938 view from outside the new Chiltern Parade included the Regent Cinema and the shopping parade to the corner of Rickmansworth Road. On the right, Hall's Hollybush Nursery occupied the plot, shortly to become Woolworths. The 1983 picture includes Woolworths, with its familiar red fascia, and its neighbour, Nobles' drapery. Now the former Woolworths store awaits a new occupier, but little else has changed.

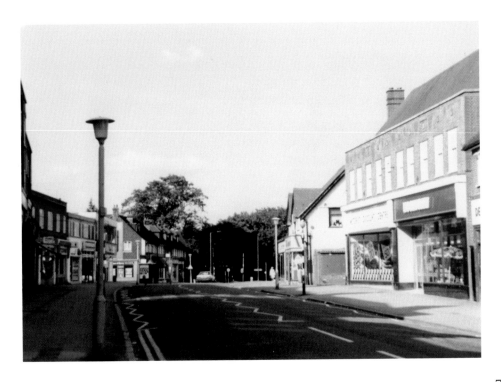

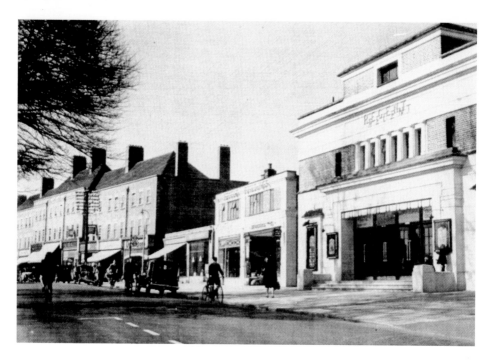

Regent Cinema

Built in 1928 on an open field, before the line of shops had reached that part of Sycamore Road, the luxurious Regent Cinema is pictured in the 1940s with Sainsbury's 1937 Chiltern Parade to the left edge. In the '50s audiences declined badly, and the second picture was taken in 1962, when demolition had started, to make way for a small supermarket and the magnificent trees on the opposite kerb were felled soon afterwards, leaving a characterless shopping street.

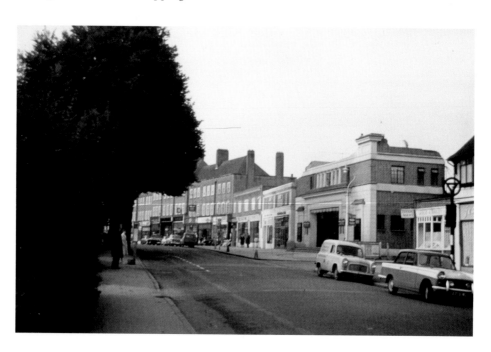

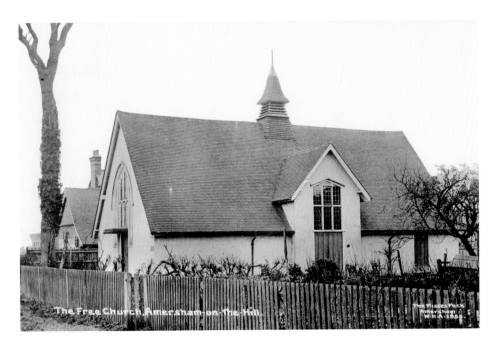

Amersham Free Church

Built in 1911, Amersham Free Church occupied a prime piece of land on Sycamore Road. It is pictured in 1925. Demolished in the sixties when it and the neighbouring St Michael's church sold most of their land, the Free Church moved to a new building on the far side of Sycamore Corner. The site was then developed with shops, and, at the extreme edge of the modern view, the new St Michael's church.

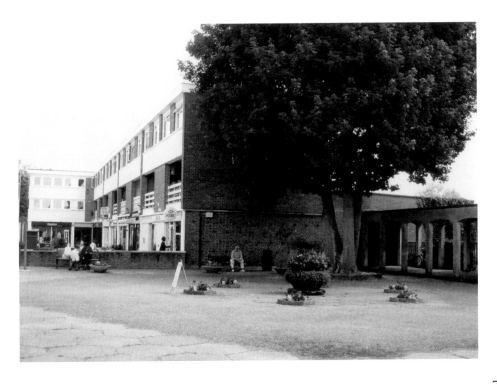

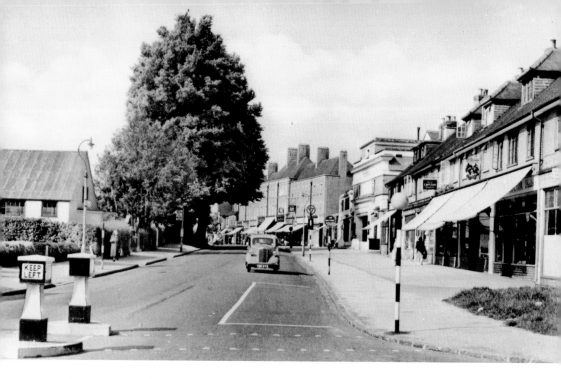

Sycamore Road

Pictured soon after the Second World War, with a government food office still occupying the end shop of Regent Parade on the right, the shopping street was then complete except for the area immediately opposite. Today's view includes the new parade of shops built well back on the former church land.

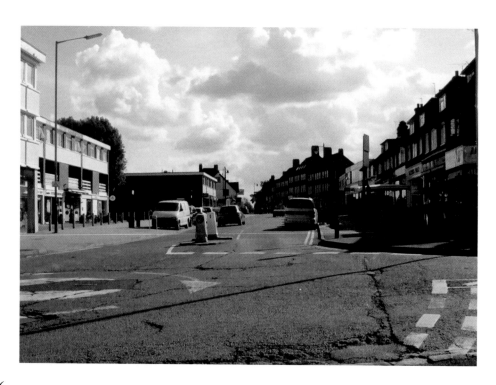

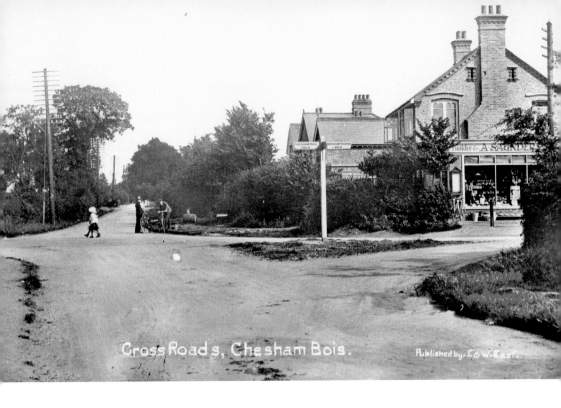

Cross Roads, Chesham Bois. Published by E. & W. East.

Sycamore Corner

The cross-roads at Sycamore Corner is pictured here in the 1930s, with Sycamore Road across the picture leading, on the right, to the main shops, which were then still some distance away. Arthur Saunders' 'General Trading Company' sold furniture from the large corner shop, and there was an assortment of small shops and houses around the corner in Woodside Road behind the signpost. The now busy road junction has since gained a pair of mini-roundabouts and modern shops on the corner.

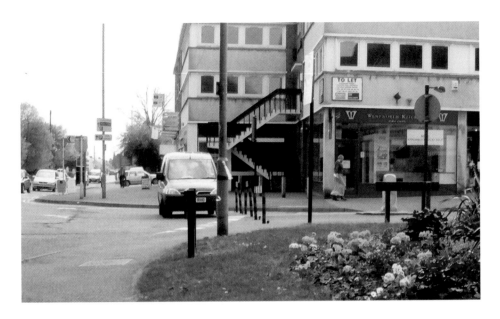

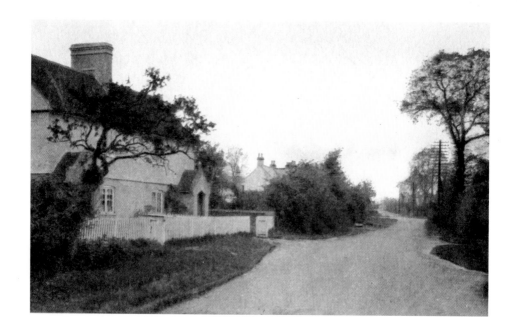

Woodside Road

This 1910 postcard shows part of Woodside Road, the main road to Rickmansworth, looking back toward Sycamore Corner from near a small roadside pond opposite the pair of nineteenth-century cottages. The cottages disappeared when the piecemeal development of shops and houses spread from Sycamore Corner between the wars, but despite more recent infilling there is still some greenery between the shops.

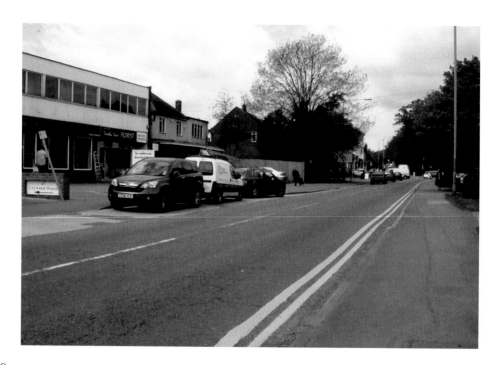

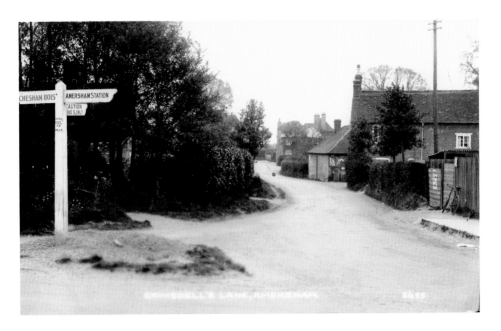

Grimsdells Corner

The forge on Amersham Common run throughout the nineteenth century by members of the Grimsdale (or Grimsdell) family continued in business until the 1950s in what had become Grimsdells Lane, seen here from Sycamore Road with a simple finger post at the junction. The forge was the first building, behind the gate at the right-hand edge of this 1925 view. The site is now occupied by the modern equivalent of the shoeing forge — a tyre depot, on a still narrow road.

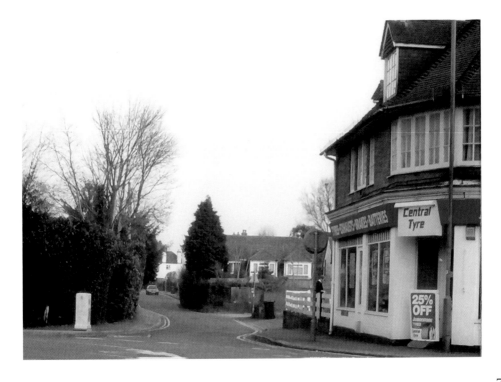

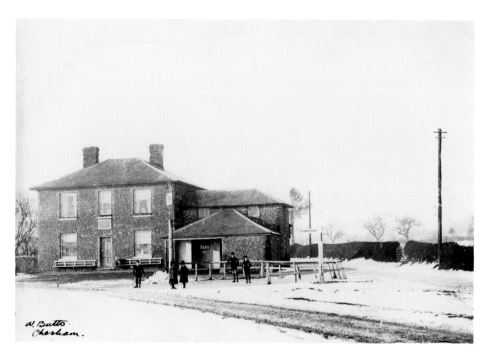

The Black Horse

The Black Horse at Amersham Common stood on the main Rickmansworth road at the junction of the road from Old Amersham (left) and the branch from the New Town (behind the pub). In 1891 the Metropolitan Railway line was built here on an embankment in between the pub and the re-aligned road, crossing the branch road on a girder bridge. Wellers closed the redundant pub and transferred the licence to the new Station Hotel. The road junction is still known as Black Horse Bridge, 118 years after the pub's demise.

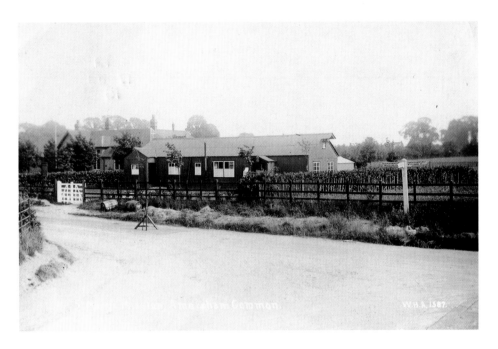

St Mary's Mission Church

Pictured in 1915 as St Mary's Mission Church, this building, roofed with corrugated iron, had a variety of uses over the years. Erected as a temporary home for workers building the Metropolitan Railway, it was rebuilt in 1907 for Amersham parish church as a mission to serve the growing community on the hill, and the interior is shown on the inset. It closed in 1935 when the new St George's church opened nearer Little Chalfont, and was then used as an overflow for the school next door until the '50s, later replaced by houses on this now busy main road junction.

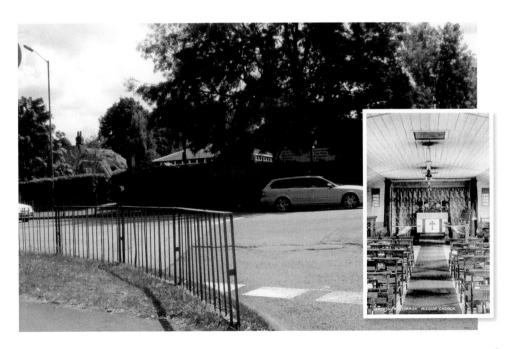

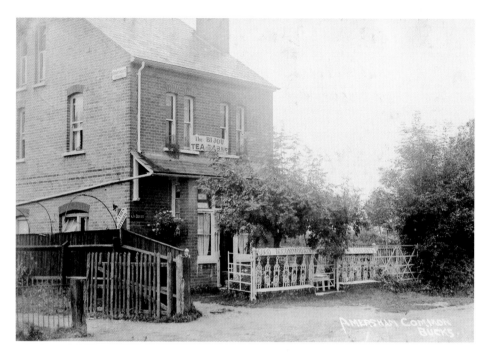

The Bijou Tea Table

A short distance from Black Horse bridge along White Lion Road, 'The Beeches'. pictured in 1908, offered accommodation and refreshment at 'The Bijou Tea Table'. Providing primarily for visiting cyclists, for twenty years it also offered a puncture repair service which, considering the state of the local road surfaces, was probably much in demand. The building was later converted into a general store.

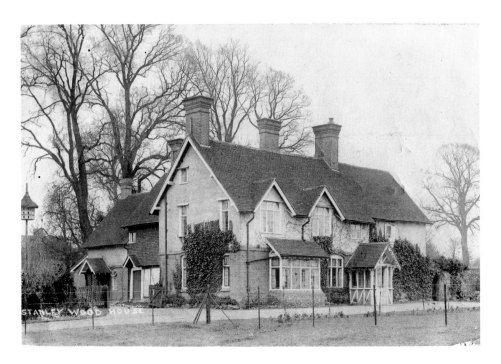

Stanley Wood House

Originally the farmhouse of Moody's Farm, Stanley Wood House, pictured here in 1905, was approached from White Lion Road along a drive between an orchard and an open field. On the edge of Reeves Farm, it was renamed Little Reeves in the '20s. In the 1950s a sawmill and a caravan factory were built on the open field, shortly followed by the houses of Little Reeves Avenue, built through the orchard and across the site of the house.

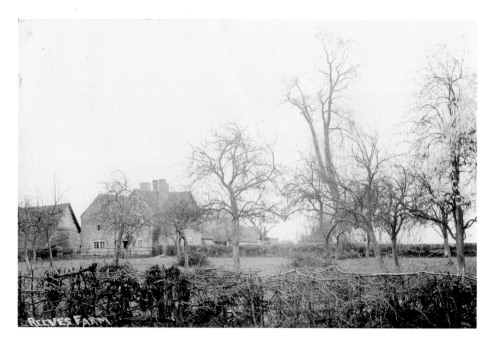

Reeves Farm

One of the farms on the edge of Amersham Common, the seventeenth-century Reeves Farm stood at the end of a private drive behind a small orchard, looking very unkempt in this 1925 photograph. In the '20s, to cater for the many visitors to Metroland, they offered refreshments and apartments with the luxury of 'hot meals and baths at all times' together with camping facilities, at a shilling per night, at 'Ye Travellers Kitchen'. In the sixties the house was demolished and a school erected on its site.

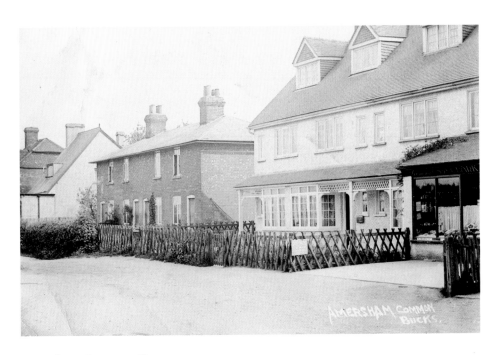

Amersham Common Shops

In the block of cottages to the right of this 1905 picture, the end one housed Clarke's general store in its front extension and next door was a small drapery in the front room. A few years later the general store was accompanied by a wardrobe dealer, a tailor and a newsagent in these cottages, with two more shops along the road towards Amersham. Now the whole block has been extended forward and fitted out as shops of various trades.

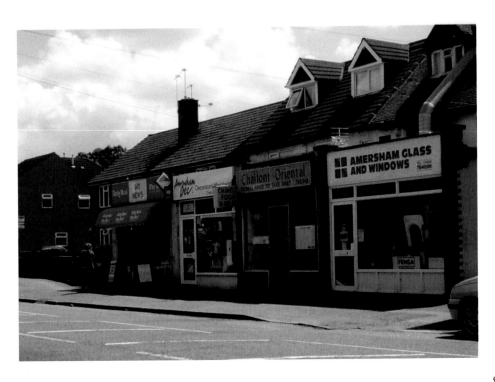

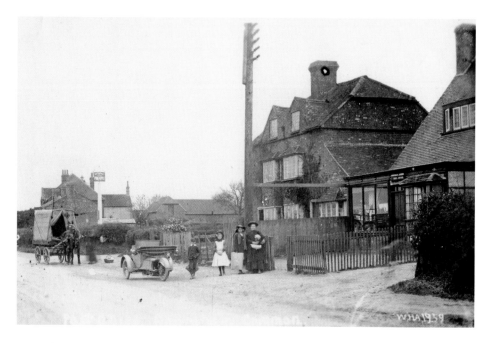

Amersham Common Post Office

Amersham Common post office, which opened in about 1900, is pictured on this postcard published some twenty years later. The telephone exchange had been installed there since 1907, still with only forty subscribers, served by overhead wires from the pole in front of the office. Then in the late '20s the post office and exchange moved to Little Chalfont. Later, the building became a betting shop, but has now reverted to residential use with the redundant telegraph pole still by the roadside, now almost hidden by trees.

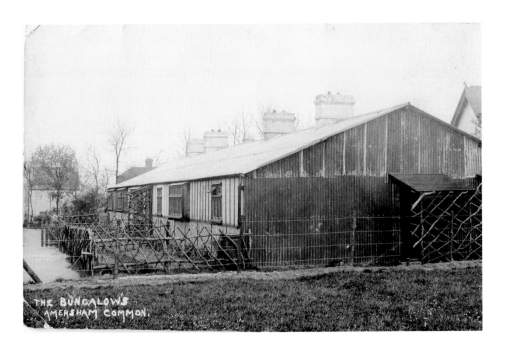

Bendrose Bungalows

The block of three Bendrose Bungalows was built around the time of the Great War on the edge of the common a good quarter mile from Bendrose Farm. In a small cul-de-sac off White Lion Road adjacent to the Pineapple Inn, the roof of which can be seen at the edge of the 1925 view, they appeared of a temporary nature, but survived until the 1960s when replaced by more conventional houses.

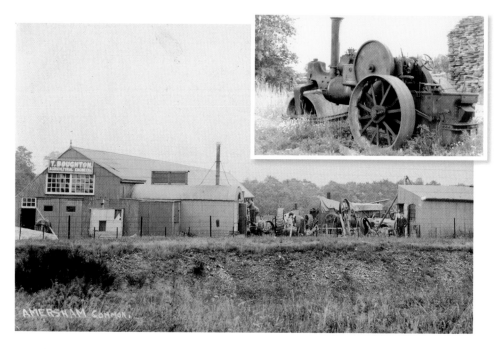

Boughton's Works

Pictured in 1920, agricultural engineers Boughtons had established their works at Amersham Common in 1906. In addition to supplying and repairing steam engines they hired out ploughing engines, threshing machines, etc. to local farmers, and road rollers to councils and estate developers. Part of the site was used for seasoning timber for the High Wycombe furniture industry and in the inset picture (1960) a steam roller stands near a stack of timber. Boughtons moved out of the area at the end of the twentieth century and the land is now occupied by warehouses and offices.

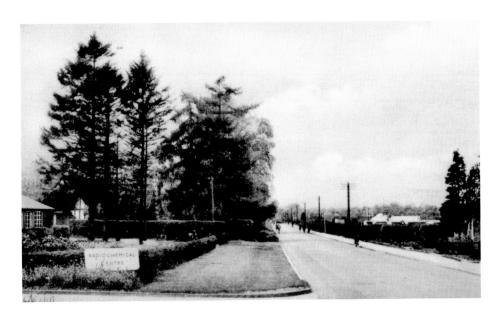

The Radiochemical Centre

Established in 1940 as Thorium Limited, making luminous paint for aircraft instruments, their range of products increased and, renamed the Radiochemical Centre, they specialised in radioactive products for pharmaceutical and research purposes. Pictured in the mid-1950s with small buildings set well back from the road, at that time they became part of the United Kingdom Atomic Energy Authority. A major exporter, they were later privatised as Amersham International, ultimately becoming part of the American G E Healthcare Group.

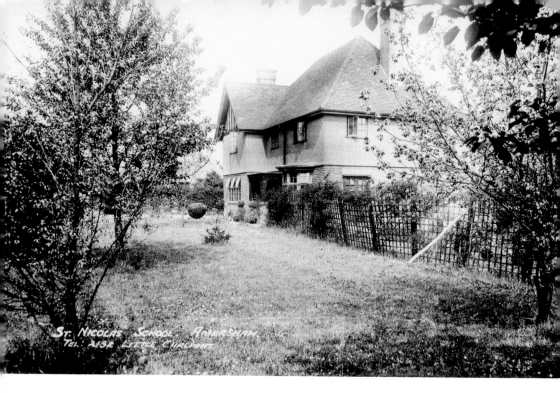

St Nicholas School

St Nicholas Preparatory School was established initially in Loudhams Road. It moved in the early 1930s to this White Lion Road building on a large plot opposite the grounds of Beel House. Toward the end of the great post-war building boom which swelled Little Chalfont's population three-fold and when little empty land remained available, St Nicholas Close was built on the site.

Loudhams Cottages

The only building on the main road through Chalfont Station Village, as it was known in 1905, Loudhams Cottages, which stood on the corner of Burtons Lane, had been built on the edge of Loudhams Farm to house its workers. The shops of Nightingales Corner (right) were built in 1930 and those of Chenies Parade (left) in 1962. The cottages were demolished in 1967 and Little Chalfont village green was created on their site.

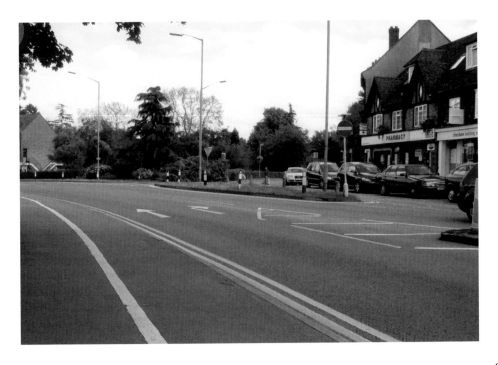

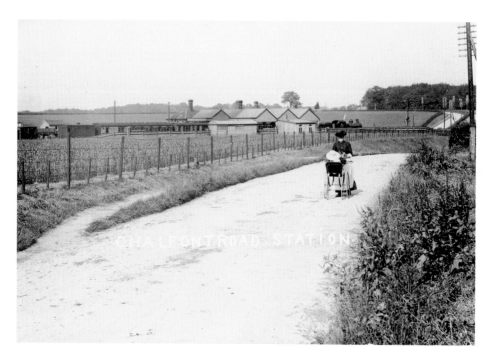

Chalfont Station Village

This was the view of Chalfont Road Station from the main road on the Amersham side in 1900, before any building had started in Chalfont Station village. The only entrance to the station was then on the up platform, reached from this side via the road under the line and up a steep slope. The original viewpoint was later surrounded by the shops of Little Chalfont, which now dominate the view.

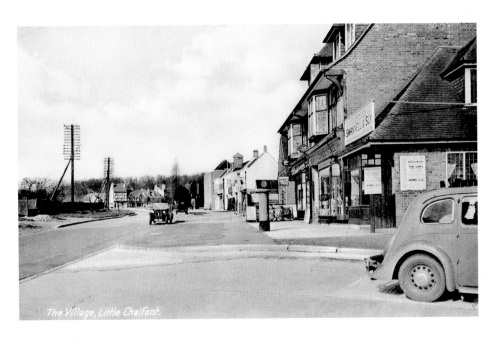

The Village, Little Chalfont.

Little Chalfont Shops

These shops, built in 1928, were the start of Little Chalfont village centre. In the distance the first shops of Nightingales Corner date from a couple of years later but the meadow to the left of the road remained undeveloped, with grazing donkeys and ponies, until 1962. The photo was taken in the mid-1930s from the newly-opened Station Approach, the long-awaited direct access to the station's down platform. Today's view includes the 1962 Chenies Parade behind its service road with evening light reflected in its upstairs windows.

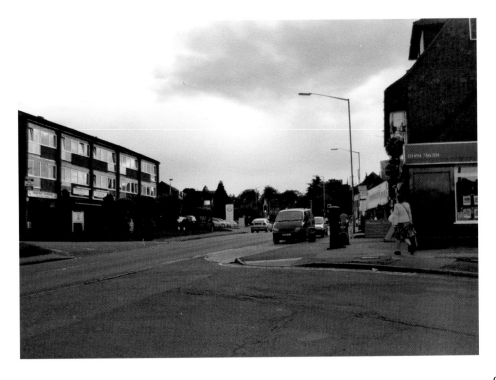

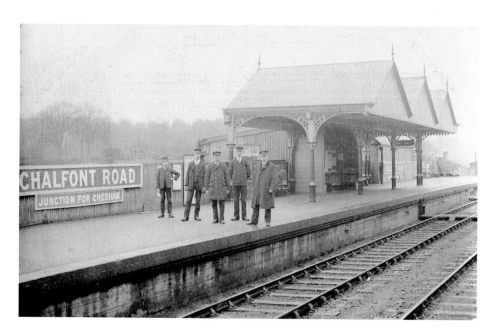

Chalfont Road Station

The Metropolitan Railway reached here in 1889 and the new station was named Chalfont Road, to suggest its proximity to the two Chalfont villages. Initially served by through trains to Chesham, when the line to Amersham was opened three years later, Chesham became a branch line served mainly by a shuttle service from here as it still is today. In a 1900 photograph, members of the station staff pose on the down platform which had no facilities and little shelter from the elements. Five years later, on a locally published postcard, smoke from the engine obscures much of the train entering the short platform. The longer up platform was better equipped, with a waiting room and a more extensive canopy, but no protection for Chesham passengers waiting at the bay platform at the left edge of the picture.

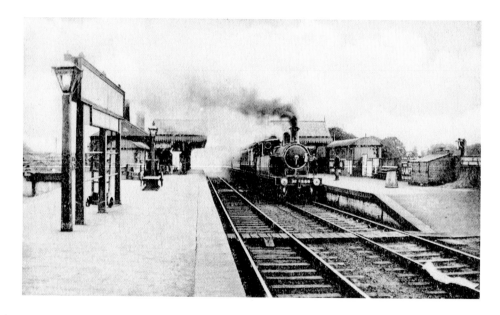

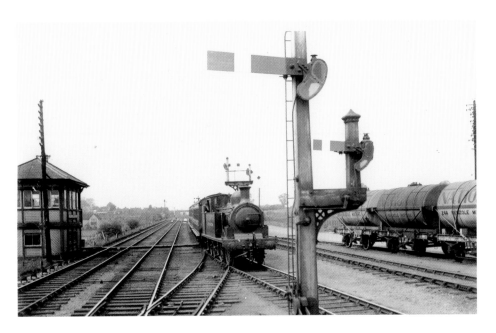

Chalfont Road Station

In this 1934 photo from the end of the platform, the 'Chesham shuttle' is approaching its platform beside a line of tank wagons carrying oil to the National Benzole depot at the foot of the embankment there, where now is the station's lower car park, The modern photo, taken before tightened security made railway photography difficult, shows the greatly extended platform canopies and a small waiting room for Chesham passengers, and the conductor rails, laid in 1962.

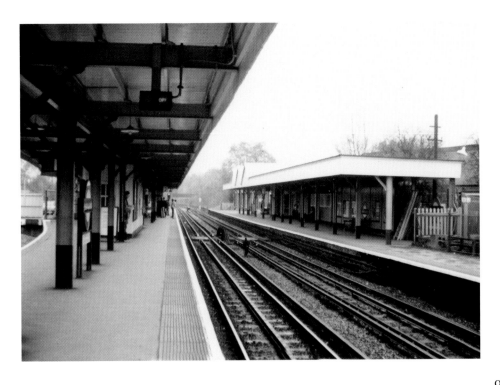

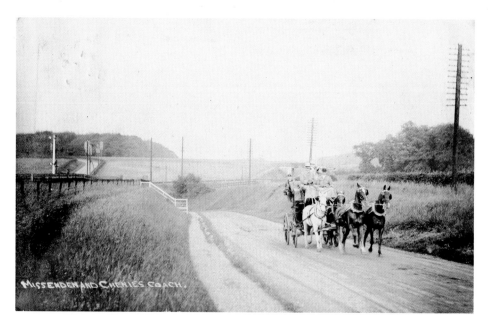

Chalfont Station Road
The 1908 tourist coach is here seen climbing from the cutting under the railway at Chalfont Road Station on a journey from Chenies to Amersham and Great Missenden.

Acknowledgements

I must thank all the unknown photographers and publishers of the original photographs and postcards used in this book. The only identified photographer is George Ward, who recorded life in the old town around the beginning of the twentieth century and I am particularly grateful to the Amersham Museum for permission to include five of their restored and enhanced Ward prints.